IMAGES
of England

AROUND
BRIGG

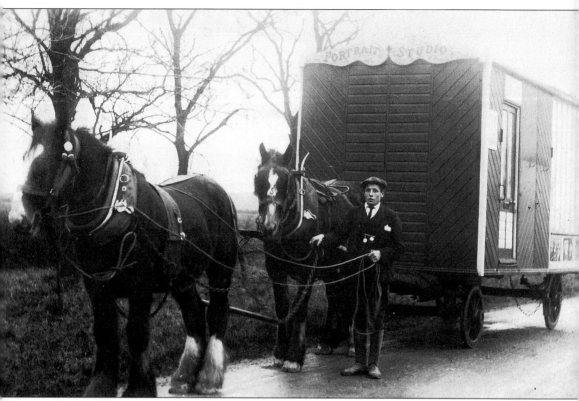

The mobile portrait studio belonging to Mr Grayson Clarke, who for almost thirty years was a resident photographer in Bridge Street, Brigg. Many of his pictures are included in this book. This horse-drawn studio would have been a familiar sight in the town and the villages. He came to Brigg around 1911 from nearby Scotter having previously worked with Mr S.A. Walker of Regent Street, London. In later years his studio was permanently sited on the corner of Bridge Street and West Terrace.

IMAGES
of England

AROUND
BRIGG

Compiled by
John & Valerie Holland

TEMPUS

Tempus Publishing Limited
The Mill, Brimscombe Port,
Stroud, Gloucestershire, GL5 2QG

ISBN 0 7524 0796 1

Typesetting and origination by
Tempus Publishing Limited
Printed in Great Britain by
Midway Clark Printing, Wiltshire

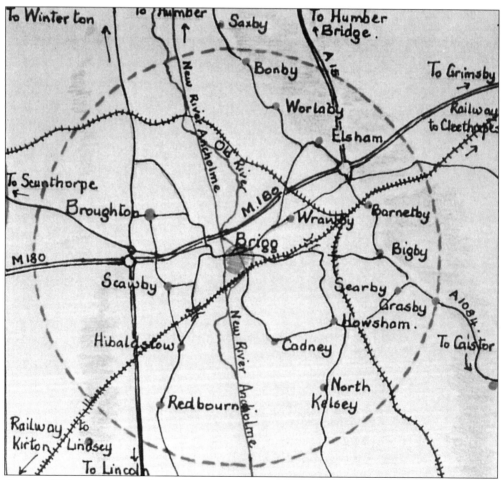

A map of Brigg and surrounding villages, represented in the book.

Contents

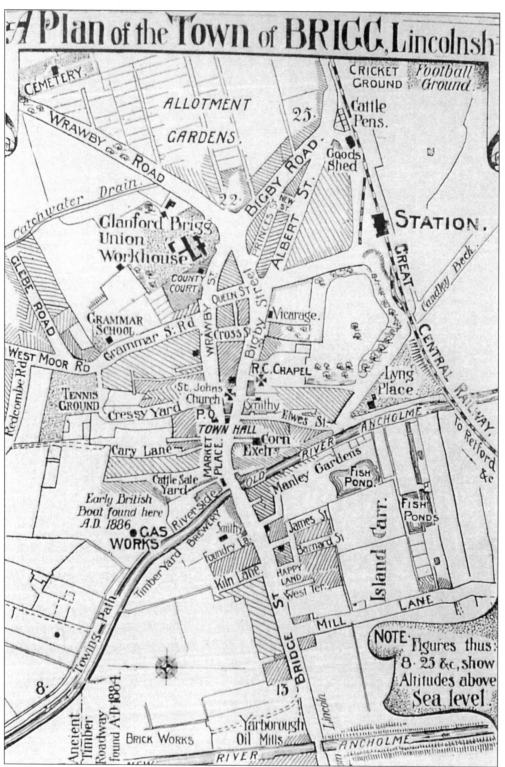

A plan of Brigg, c. 1906.

Introduction

For the last twenty years we have collected local pictures and ephemera of North Lincolnshire, developing an ever increasing interest in the towns and villages of this part of the country. What started as a small topic of work at the school in which I taught, with the visit of Queen Elizabeth II to Brigg in 1977, has mushroomed into a great and time consuming hobby. Then, a local history topic required the school to find local old pictures, old postcards and newspaper advertisements to display for the school exhibition. As I was the keen and enthusiastic school amateur photographer, I got the job. Research had to be carried out to find the old records of daily life in Brigg from fifty or more years ago, which were borrowed from the older generations in the town. These people had to be visited and asked whether they possessed any old photographs, school groups, postcards, or anything connected with the area that could be borrowed for the school exhibition. Luckily, both Valerie and I were born and bred in Brigg, so the older people knew us from our childhood days and willingly encouraged us 'young uns'. They lent us whatever they had so we could copy the days of their childhood. Many hours were spent in their homes listening to, or taping, their reminiscences as we borrowed or returned their possessions. Visiting the homes of the older generations, looking at their old pictures as they trustingly let us borrow them and learning much locally from their stories over many cups of tea, was the beginning of the hobby we share. It is an interest we started as relative youngsters, but have been encouraged by our elders in Brigg, who over the last twenty years have been so kind to us seeing us as 'a good home' for some of their local possessions. Very soon after the Silver Jubilee exhibition of 1977, I was asked to make slides of the old postcard type pictures and do shows in the area, and the hobby took another step forward. However, a problem arose when I wanted to improve my photography copies for slides. When I asked the local people if I could re-borrow their old pictures, they invariably remarked, 'We've thrown them away, why didn't you say?'. These remarks surprised and upset us. To think that the older folk thought the people would have no interest in pictures of their youth made us determined to set about collecting such bygone ephemera and pictures of our area. This was the final phase in the beginning of our hobby of serious postcard collecting. It has

taken us all over the country and we have made some wonderful friends in the process.

Ninety per cent of the pictures in this book are from our own collection. They are of Brigg and fifteen surrounding villages within a six mile radius of the town. In compiling this book we have attempted to record daily life in Brigg and district as it was between fifty and one hundred years ago. Two hundred and thirty pictures have been selected. We found it a difficult task to decide which ones to put in and which ones to leave out. Many have not been published before.

Brigg, or Glanford Bridge, had developed into a prosperous market town by the time of these photographs. The River Ancholme flowing north to the River Humber was an important commercial waterway connecting Brigg with the large port of Hull, linking the Ancholme villages by a service of steamboats. The road network converging at this bridging point further helped the town, as did the coming of the railway. Brigg as a market town seemed to have everything. Our old photographs show most trades were represented and deliveries to outlying areas were normal practice. There are still plenty of shops in the town where service is as willing as ever and the Thursday market continues to be attractive.

A carrier service was of great importance to people living in the country area and many ran services to Brigg especially on market days, collecting items of sale and executing commissions in the town. The villages were on the whole self-contained communities. Employment was provided by the large farms and estates with just a few travelling to jobs in the town as transport improved. Each village had a blacksmith, his forge being one of the centres of village life, most places also had a windmill which ground local corn. The churches provided for spiritual welfare, and often with the help of the lord of the manor, the children's education. Bakers baked their own bread, grocers patted up butter and weighed sugar into blue bags. Milk was delivered door to door in cans by local producers, mainly small farmers. The postmaster or mistress, along with the village innkeeper and football and cricket teams, was often the stalwart of the community.

Our pictures of the region portray a slower and more pleasant way of life, when the horse and cart were the chief means of transport in contrast with the motor vehicles of today. In reality, the times recorded here for a great many people were hard with often small return for a life of toil. It may be true, though, that life was more in tune with the natural world.

We have put a great deal of effort in compiling this book and have spent a lot of time visiting and talking to local people of an older generation across the region. It is hoped the reader will get as much enjoyment from the photographs as we have had scouring the country in search of them.

John Holland
April 1997

One

The River Ancholme and its Industries

A pre-historic log boat unearthed when excavations were in progress in 1886 for the purpose of building a new gasometer. It was discovered by workmen belonging to the Brigg Gas Company on land belonging to the lord of the manor, V.D.H. Cary-Elwes Esq, who had a shed especially built to house it until it was removed to Hull Museum in 1909. It was destroyed by bombing during the Second World War, perhaps the most famous of Brigg's old relics.

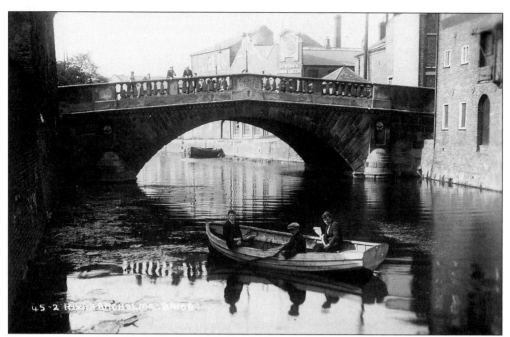

A quiet day on the Old River Ancholme in the late 1920s. Spring's jam factory can be seen beyond the county bridge which was built in 1828. The balustrades became eroded by the weather and had to be replaced in the 1960s by metal ones.

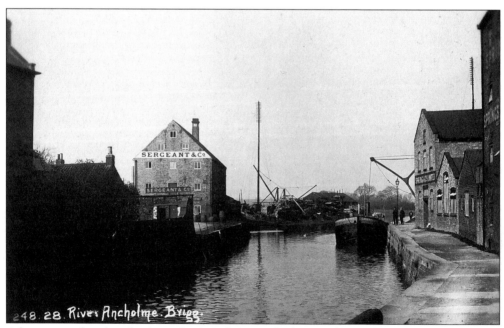

A boat moored at the wharf near Spring's factory, which carried cargo between Brigg and Hull, in 1920. On the opposite bank stands the brewery of Sergeant and Co. erected in 1852. A very popular ale was made from the spring water at Castlethorpe where Sergeants also had their maltings. The brewery closed in 1967.

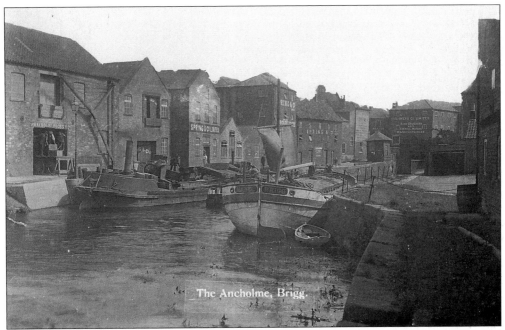

A very busy scene on the river, where extensive factories and warehouses had been established on the banks close to the county bridge, *c.* 1912. The Ancholme Packet Co., Spring and Co., the Farmers' Co., on the far bank, and Sergeant's Brewery can all be seen in this photograph.

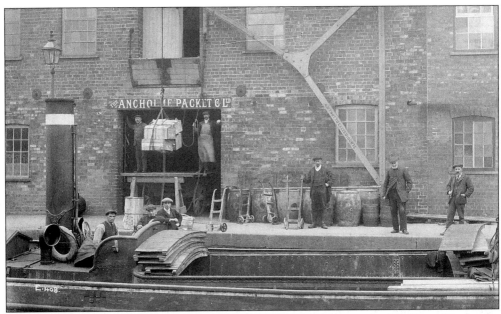

The Ancholme Packet Company's steam boat at the wharf, Riverside. Mr Harry Hardy, the manager, is pictured far right. Their boats called at several places on the Ancholme including Broughton and Bonby on Mondays and Thursdays on their way to Corporation Pier at Hull, returning on Tuesdays and Fridays.

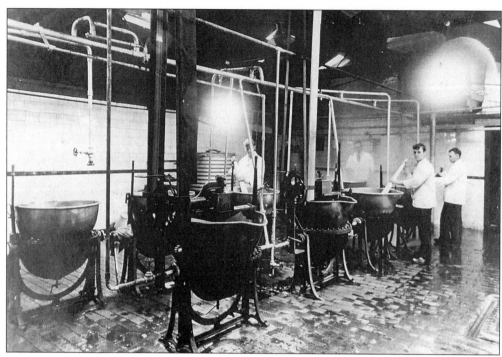

Inside Spring's factory, workers are engaged in the manufacture of quality jams in the 1930s. These jams were made 'using only fresh fruit and refined sugar during the actual fruit-growing season, and were in every respect "home-made"'. The firm was one of the town's major employers.

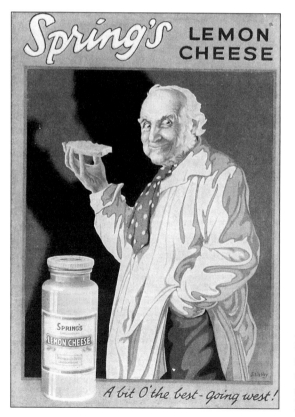

An advertising card for Spring's Lemon Cheese, also known as lemon curd. At the turn of the century, Spring's lemon curd was already famous throughout the country, pronounced by connoisseurs to be the very best on the market.

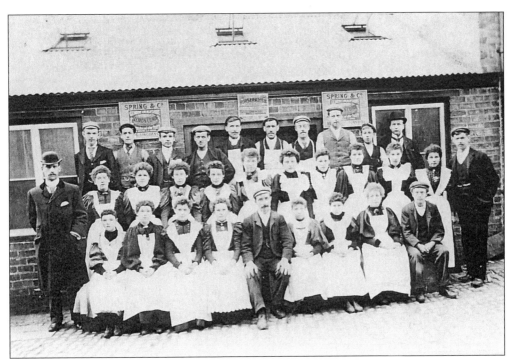

Spring's workers pictured outside their original premises in Coney Court, where horseradish cream was made. It was stated to be 'pungent and palatable forming a smooth acceptable relish for roast beef', and even appeared on Queen Victoria's table receiving royal approval. The company ceased trading in the late 1970s.

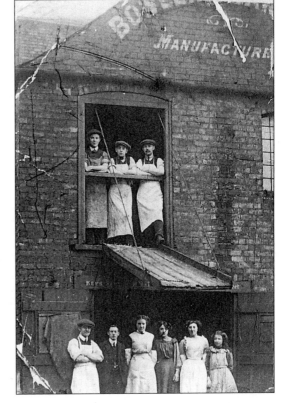

Some of the workers outside the factory of Bowler, Clarke and Co., manufacturers of lemon curd, jellies and fruit syrups, situated off Bridge Street in Engine Street. In 1904, Mr Herbert Clarke left his job as foreman for Spring and Co. to join others in forming this company.

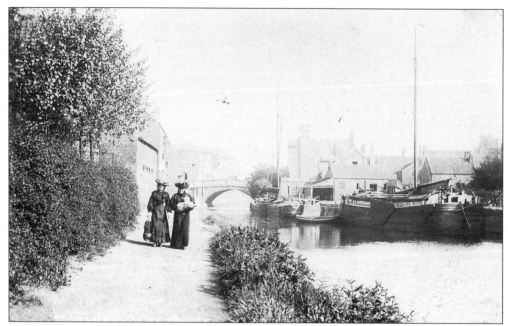

Two ladies take a stroll along the towpath in Brigg, 1913. The barges are moored at Sergeant's wharf.

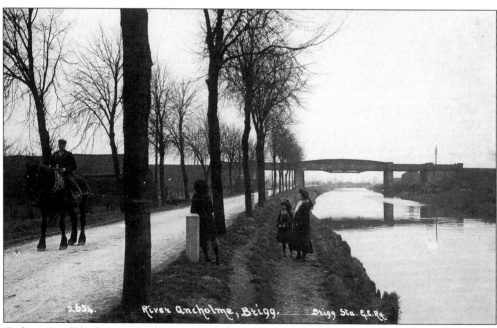

Cadney Road, looking towards Cadney, *c.* 1909. The bridge carried the Great Central Railway over the Old River Ancholme.

14

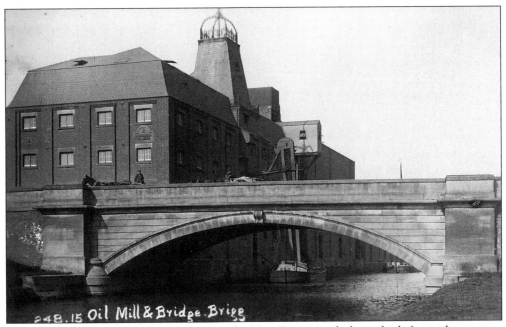

248.15 Oil Mill & Bridge Brigg

Yarborough Oil Mills and the bridge over the New River Ancholme which forms the western boundary to the town. This new river was cut between 1635 and 1639 to assist the drainage of the marshes. The mills were rebuilt after a fire in 1910 and look in a marvellous condition in this picture of 1920.

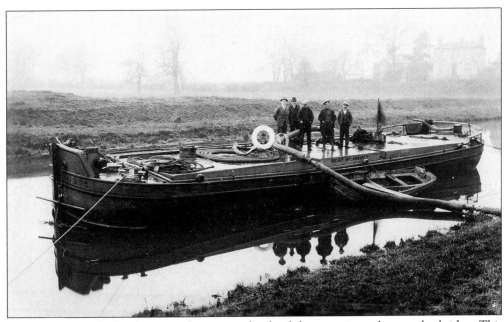

Shell Petroleum had a depot on the eastern bank of the new river close to the bridge. This picture was taken during installation at the Brigg depot in 1927.

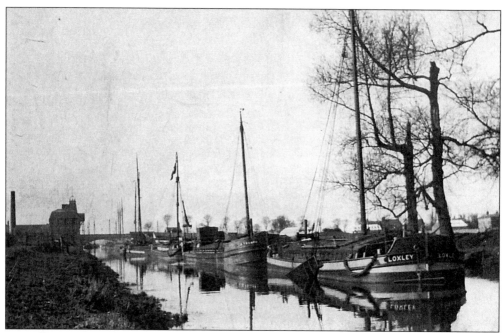

Lots of barges, with the Yarborough Oil Mills in the distance, 27 April 1929. They are carrying the first cargoes of raw sugar cane from Cuba to the new sugar factory at Brigg.

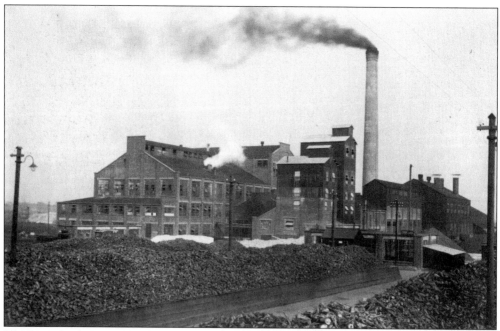

The Brigg Sugar Factory which was built in 1928. Full production began only nine months after the building was completed and it was a great boon to the town. The factory provided new employment to Brigg. The surrounding districts benefited materially by the additional labour employed in growing thousands of acres of sugar beet required by the factory. It was closed in 1991.

Two

The Market Place and Thoroughfares

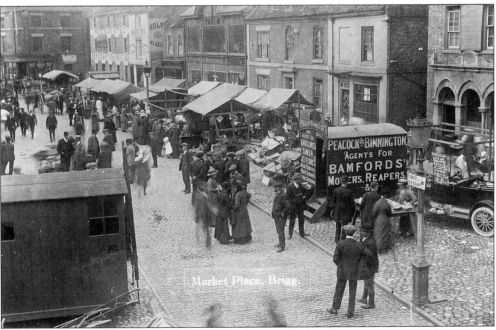

The Market Place on a Thursday, *c.* 1914. A typical Lincolnshire country market, with a profusion of canvas-topped stalls assembled in an old world market place. From left to right can be seen an ironmongers, two public houses, new garage premises, Dr Frith's house, a shoe shop and to the right of Cary Lane, a brewery.

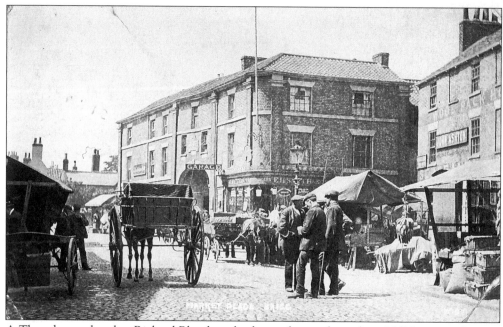

A Thursday market day. Richard Bloodworth, the market gardener from Mill Lane can be seen arriving with his horse and cart to do business in the cobbled market place. Other traders from the surrounding district are helping to create a busy and thriving atmosphere. Market day was the most important day of the week and still is today.

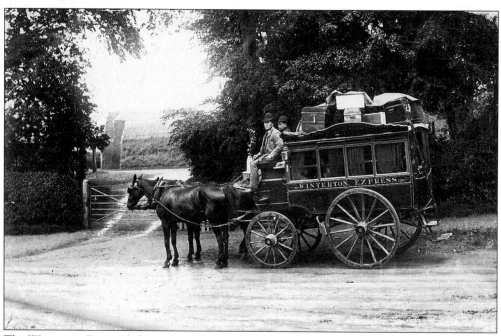

The Winterton Express belonged to George Harrison and Son, omnibus proprietors and carriers who operated between the Woolpack Hotel in Brigg Market Place and Winterton, calling at Appleby Station. The service was provided on Mondays, Thursdays and Saturdays.

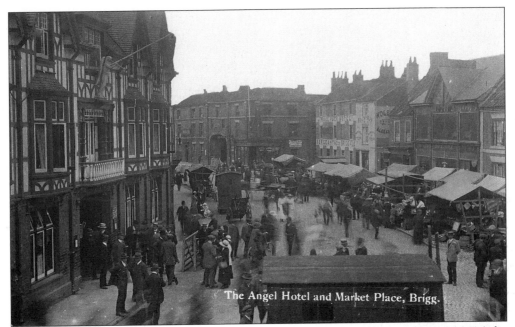

The Angel Hotel and Market Place, Brigg.

The Angel Hotel is a reminder of the good old coach and posting days, *c.* 1914. In 1896 the whole of the frontage of the hotel was rebuilt, cleverly simulating a building of far greater age. The hotel was very popular with farmers and corn and potato merchants who did much business in the courtyard on Thursdays.

Lacey and Clark was situated in the Market Place close to the Angel Hotel, in premises which are now a part of the Lord Nelson Hotel. It was a high class ladies' outfitters with its own Corner House Cafe and hairdressing department upstairs. One wonders whether a visit to the hairdressers in the 1930s was as daunting as it appears from this picture!

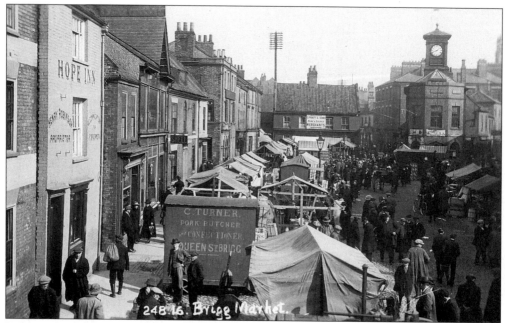

Brigg market looking toward Wrawby Street and Bigby Street in the 1920s. The Town Hall building surmounted by a clock turret provided a council chamber on the first floor and a butter market below. Pratts, wine merchants, became the National Provincial Bank in the late 1920s. The tall telegraph pole indicates Brigg's Telegraph and Post Office which was just behind Pratts in Wrawby Street.

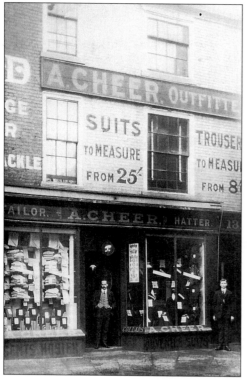

A. Cheer, outfitters, in the Market Place, with Mr Walter Shaw in the doorway. It was opened in 1906 and managed by Mr Shaw who bought the business in 1913, and renamed it Walter H. Shaw. It is still in existence today owned by his grandson, Mr Michael Shaw.

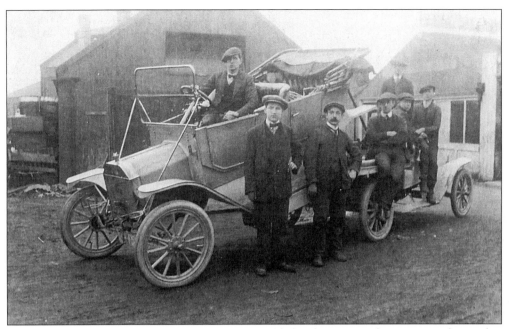

An early Model T Ford towed in for repair pictured behind E. H. Smith's garage in the Market Place.

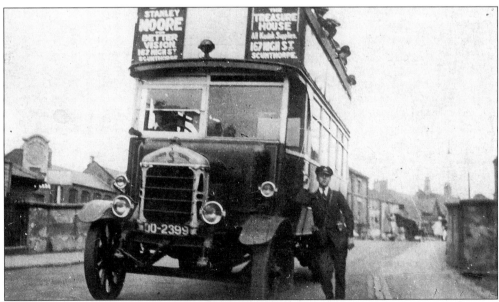

A Scunthorpe bus just about to leave the Market Place with a full complement of passengers. The bus is at rest on the county bridge leading into Bridge Street. Spring's factory can be seen to the left.

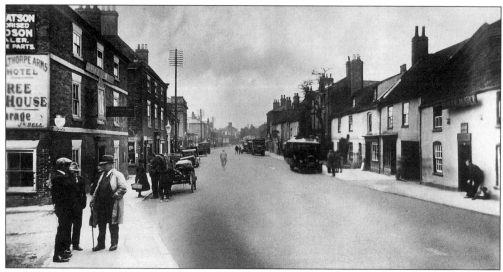

Bridge Street looking west in the late 1920s. This was the main road into Brigg from Scunthorpe and Lincoln, but is not a through route at the present time. The Nelthorpe Arms is on the left and the White Hart to the right.

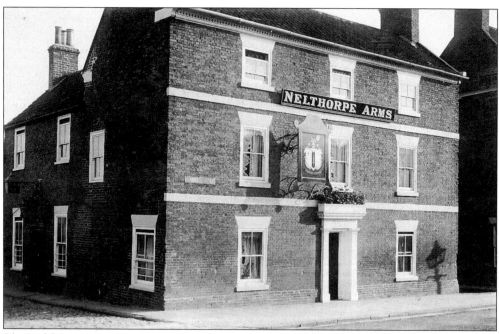

The Nelthorpe Arms Hotel is situated close to the county bridge. The landlord at this time was Mr William Jeffrey. It was an old established hotel in the early 1900s which catered for commercial gentlemen and fishing parties. The crest of the Nelthorpe family of Scawby is displayed above the doorway.

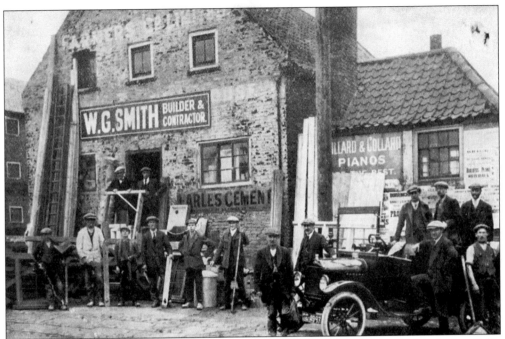

An imposing picture of W.G. Smith, building contractor, which later became Mr Arthur Bell's first furniture shop, c. 1920. These premises were between the county bridge and the Nelthorpe Arms. In more recent times, Chaplins, potato merchants, used the building but it is now demolished and a beer garden for the Nelthorpe Arms has replaced it.

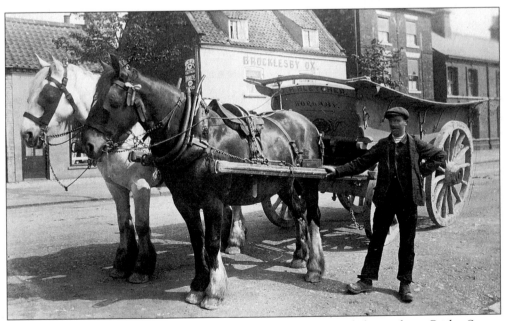

The waggoner stops to pose for Mr Grayson Clarke's camera outside his studio in Bridge Street. The horses and waggon belonged to Mr J.H. Bletcher of Worlaby.

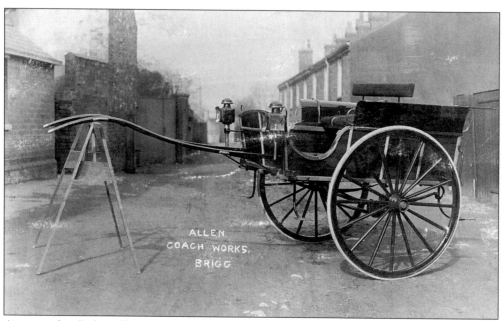

An example of John Allen's coach work, a governess cart, photographed in Engine Street at the rear of his premises. The houses in the background were demolished many years ago.

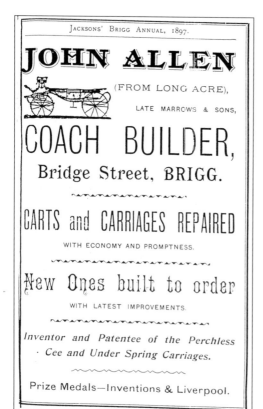

John Allen came from London in the late 1880s to take over the carriage building works of Marrows and Sons. He occupied large premises on Bridge Street which were taken over by Mr Arthur Bell, the furnisher, in the 1930s.

24

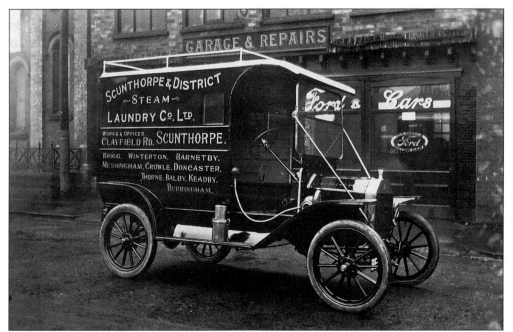

Allen's later progressed to making cars and light vans. The chassis of Model T Fords were brought in and bodies built on them. A newly-completed van supplied to the Scunthorpe and District Laundry is parked outside the front of the premises and captured on film by Mr Grayson Clarke.

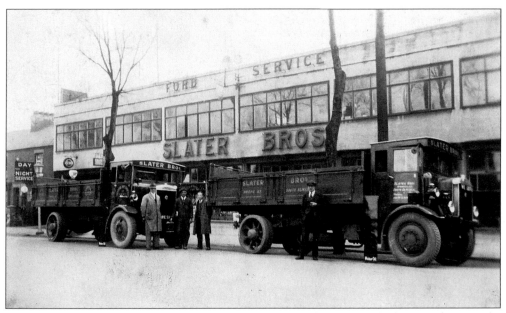

John Allen eventually moved to premises further along Bridge Street, which were taken over by Slater Bros. after Allen's went out of business in the mid 1920s. These two lorries, belonging to Slaters, clearly demonstrate the increasing use of road transport at that time. The photographer, Grayson Clarke, lived next door to the garage where he advertised his 'Day and Night' service. The Texaco garage is now on this site.

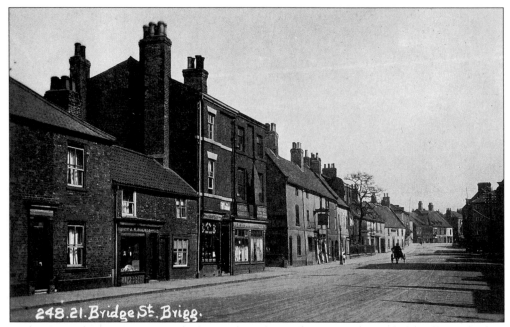

Bridge Street looking east towards the Market Place. This scene changed radically in the late 1980s when the first four buildings on the left were demolished to make way for a new relief road. Foundry Lane situated between them and the next block also disappeared.

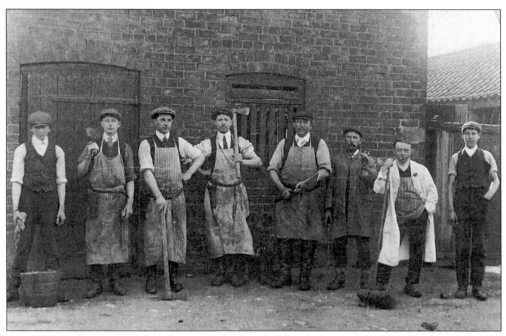

A pre-1914 photograph of workers outside the slaughterhouse in Foundry Lane. Mr Thomas Hunsley was the chief butcher and animals were slaughtered here for other local butchers.

26

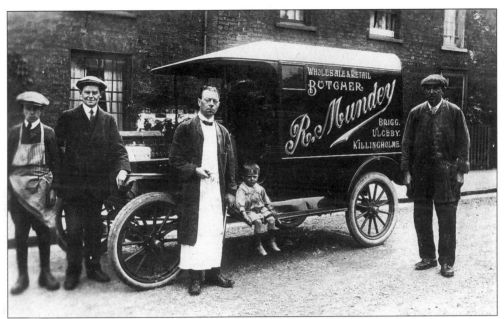

Mr R. Mundey's butchers van in West Terrace around eighty years ago. Johnny Whelpton is leaning on the bonnet. Albert Lancaster is the butcher with his son, Horace, seated on the running board.

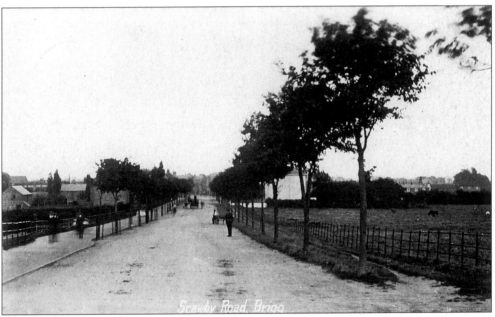

Looking back into Brigg from the bridge over the New River Ancholme in 1910. The newly planted lime trees were common to all the roads leading into the town. The field on the right was used for the Lincolnshire Agricultural Shows in 1880, 1891 and 1911. Mill Lane is just behind the white house.

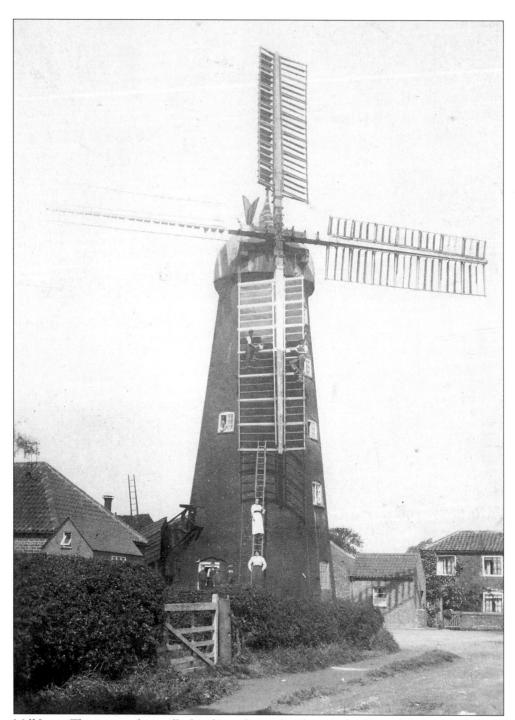

Mill Lane. This is one of six mills that formerly stood within a mile of Brigg Market Place. It was built in 1836/37 at a cost of £900. In 1920 the sails and top were removed after a sail broke. The five pairs of millstones, were then engine powered during their ownership by the Bell family until 1956. In the picture the sails are being painted and the two ladies on the ladder are the two Misses Bell.

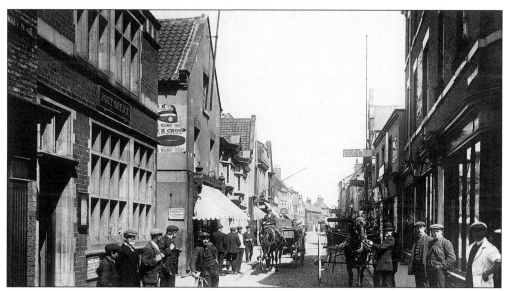

Looking up Wrawby Street from the Market Place, one sees the principal street of the town, the main shopping area, *c.* 1910. The post office on the left is number one. The street which was always busy with traffic has very recently been pedestrianised.

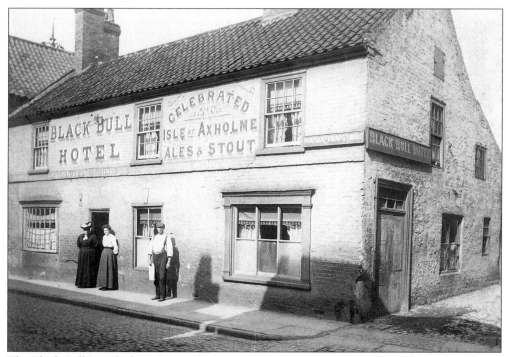

The Black Bull Hotel when the landlord was Charles Beel, 1905. The frontage was altered soon afterwards. At this time, the hotel had extensive stabling at the rear with horses and traps for hire. It also advertised a first class billiards table and that it was open on Sundays.

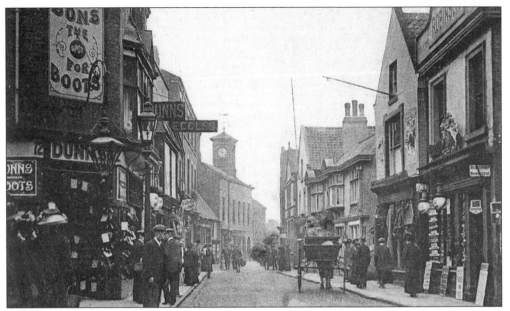

This postcard picture of Wrawby Street was published by Mr W.B. Robinson whose stationers shop can be seen on the right, with the new facade of the Black Bull after alterations. On the left is Dunn's shoe shop, now Shoefayre. The town clock is in the distance.

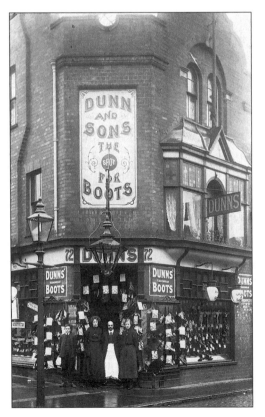

An excellent photograph of the manager and three shop assistants outside Dunn's shoe shop established here in 1893. Amazingly the building remains very much the same in appearance and is still a shoe shop.

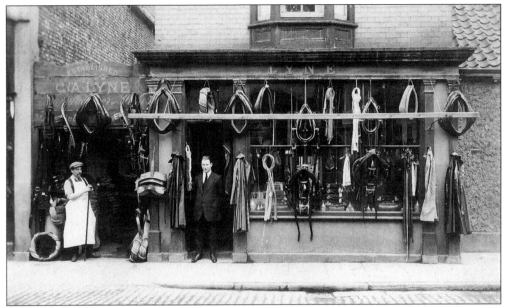

The shop of George A. Lyne, one of the oldest names in the street. He had three important businesses; saddlery, agricultural and garden seeds and a ropery. Mr Cook, in the doorway, was the manager. The business continued until the 1980s.

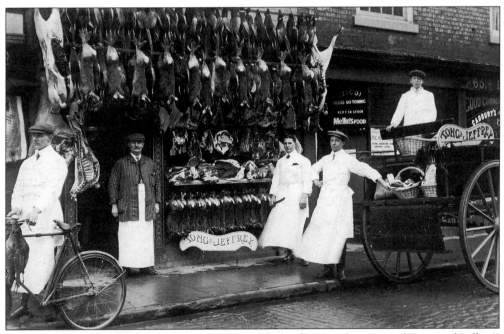

Wilmore and Sons of Bridge Street were responsible for this superb picture of Tong and Jeffrey's butchers shop at No.63 Wrawby Street in 1913. Mr George Winterbottom is on the delivery cart, Mr W.E. Knight in the doorway and Mr Fred Jeffrey holds a knife in his hand. Within a year, Mr Fred Jeffrey was the sole name above the shop.

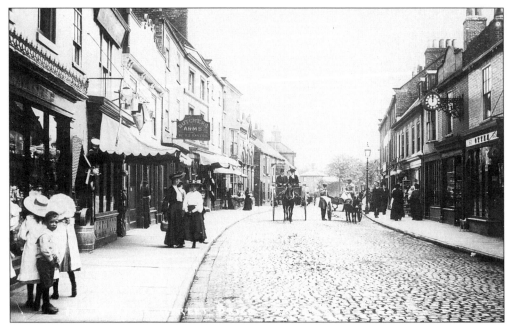

A delightful scene in Wrawby Street in the first decade of this century. The pony and trap with its well-dressed occupants contrasts with the donkey cart. The picture shows two beer houses on the left, the Butchers Arms run by Henry Sayers and the Rose and Crown by Henry Hutchinson, who was also the local joiner. The clock belonged to John Dent, watchmaker, at No.61 Wrawby Street.

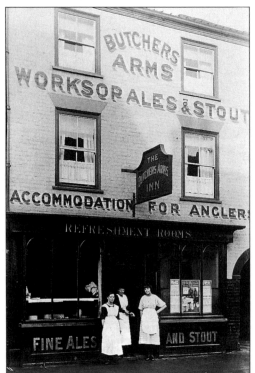

The Butchers Arms was a popular haunt for the fishermen who came from the Sheffield area in great numbers by train to fish in the River Ancholme. Large parties were catered for in the refreshment rooms at the rear. Mouth-watering hams and other meats were displayed in the windows. Today it is a restaurant.

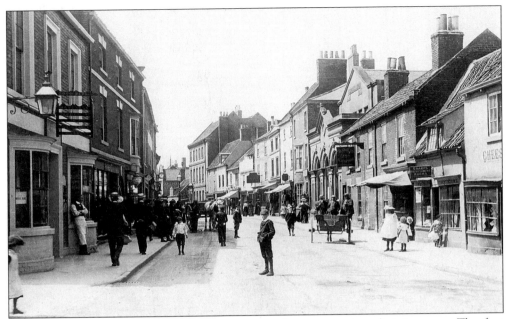

Wrawby Street seen from the other direction to the one on the adjoining page. The first building on the left was then the Waverley Hotel and next door at No. 54 was Charles Parker's book shop. On the right, afternoon tea was provided at Sharp's refreshments rooms, whilst next door at No. 20 was Arthur Cheesman, the plumber and glazier.

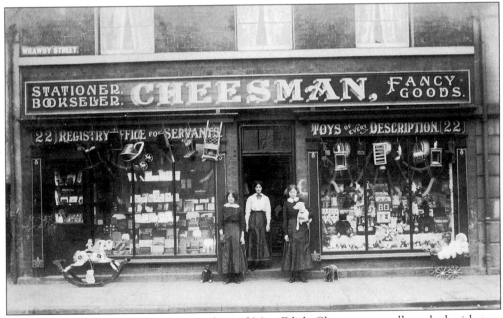

No.22 Wrawby Street, the stationers shop of Miss Edith Cheeseman, well-stocked with toys and gifts, Christmas 1913. Miss Leeson is standing to the left of the door and Miss Hackford has the dog in her arms.

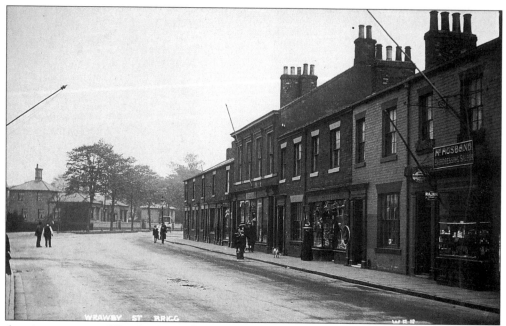

A quieter scene in Wrawby Street leading to the old police station situated behind the lime trees. Sutton Bean's brewery was opposite the police station, just off camera. At No.49 was the grocer, Harry Stamp, who donated the war memorial to the town later in 1919.

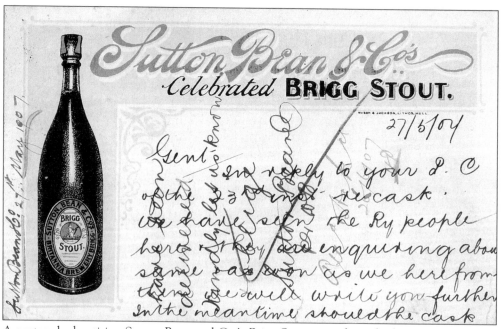

A postcard advertising Sutton Bean and Co.'s Brigg Stout, sent from the brewery in Wrawby Street to a customer in County Down in Ireland, 1907.

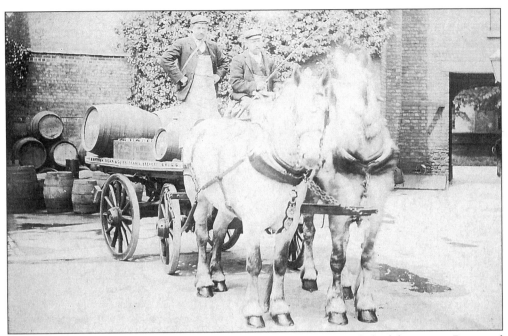

One of Sutton Bean's drays at the Britannia brewery ready for its daily deliveries in Brigg and district. They were a familiar sight until the brewery closed at the end of 1924.

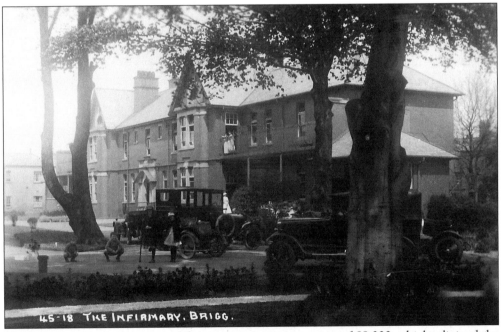

45-18 THE INFIRMARY. BRIGG.

The Infirmary was built as part of the poor institution, at a cost of £8,000, which adjoined the old police station. It was opened in 1915 by R.W. Godfrey, Chairman of the Brigg Board of Guardians. Originally known as the County Infirmary it was later renamed Glanford Hospital. It became a victim of health cuts and reorganisation in 1991 and it has been converted to offices for the area's health departments and is now known as Health Place.

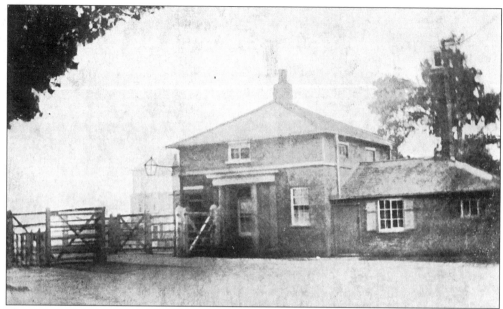

There were locks and bars on all the roads leading into Brigg to keep out all vehicular traffic until they had paid the toll for the use and maintenance of the roads. This toll bar and house were situated at the end of Wrawby Street. Tolls in Brigg were finally abolished in August 1872.

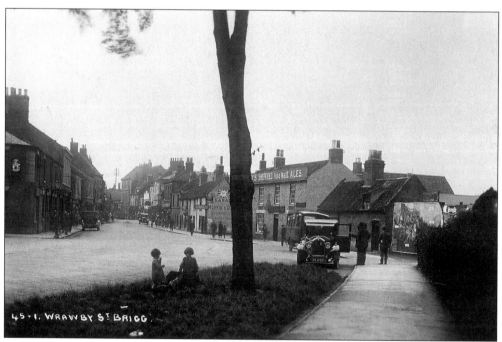

Wrawby Street, looking from the old police station towards the Market Place, c. 1927. The Grand Cinema was built on the site where the advertising hoardings can be seen. The cottage next to them has been replaced by a hairdressers but the White Horse Hotel remains unchanged.

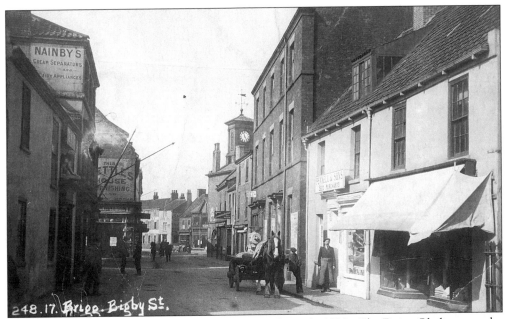

Bigby Street looking back into the Market Place in the early 1920s. The Dying Gladiator on the left is believed to be the only pub so named in the country. The landlord at this time was Mr Cyril Clark. Cadney and Howsham are signposted to the left.

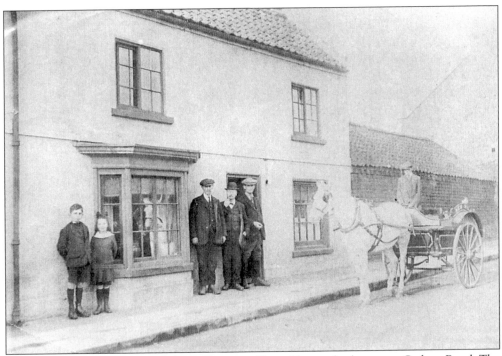

John Sumpter's farmhouse with his milk cart in Elwes Street, also known as Cadney Road. The farmyard backed on to the Old River Ancholme. He supplied milk until the 1950s.

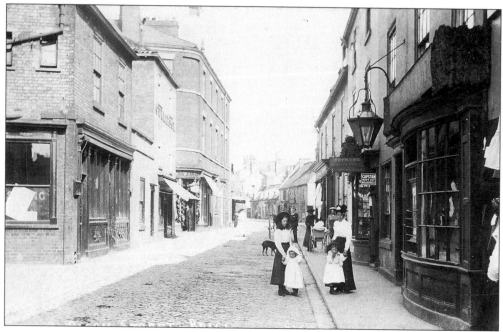

A charming moment in Bigby Street, ninety years ago. The young ladies are standing outside John Rayners, the tobacconist next to the Lord Nelson Hotel. The Manor House is in the far distance. What is now Lloyds Bank, was in 1907 S.E. Walker's boot and shoe business which later moved to Wrawby Street.

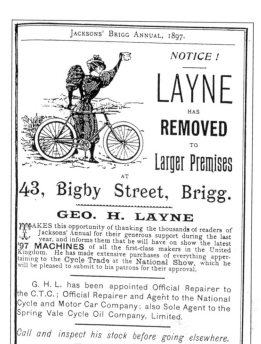

George Layne established a cycle business in Market Lane in Brigg in 1893, moving to larger premises at No.43 Bigby Street in 1896 where he was eventually to have his motor car business.

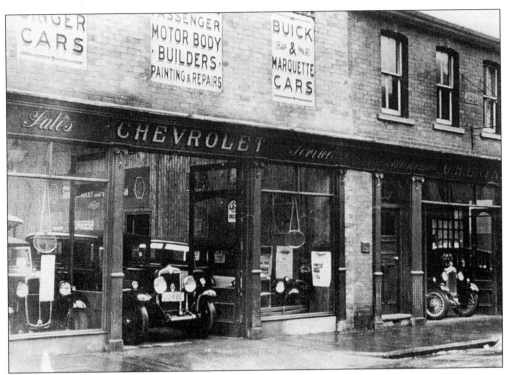

The premises of George Layne in Bigby
Street were altered in 1914 to provide
car showrooms and enlarged again in
1930. Laynes sold their first Chevrolet
car in 1920 which brought them into
contact with General Motors.

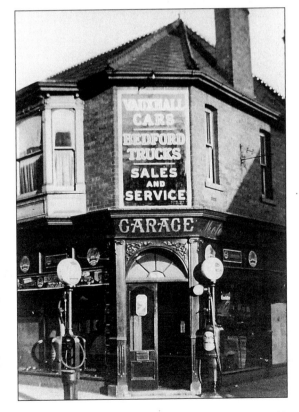

Laynes later became sole Vauxhall and
Bedford dealers. Service facilities were
provided with extensive workshops to
the rear. At its height the firm also had
branches in Scunthorpe, Crowle and
Market Rasen. The Brigg premises are
now used as a snooker club.

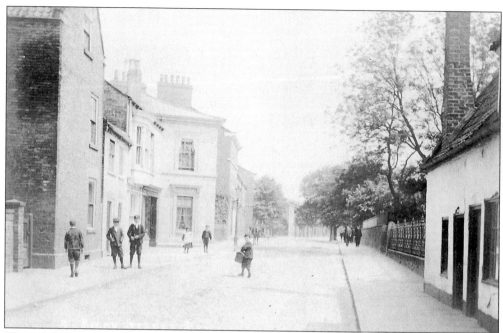

More children to delight the eye in Bigby Street outside the Catholic school's railings, 1908. The houses beyond Cross Street on the left were built as part of the expansion of Brigg following the coming of the railway.

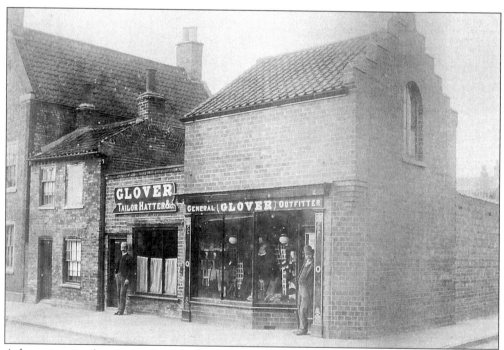

A late-nineteenth-century picture of Robert Glover's outfitters and tailors on the corner of Bigby Street and Cross Street. By 1896 the hatters shop had become a poultry and game outlet, but was still run by Robert Glover.

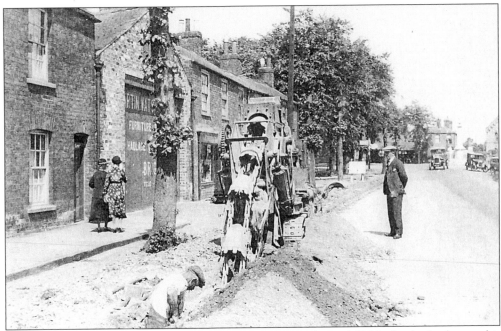

Cable laying in Bigby Road for Brigg's new post office in the mid 1930s. In the background is the war memorial and the cars are outside the garage belonging to W.A. Sass.

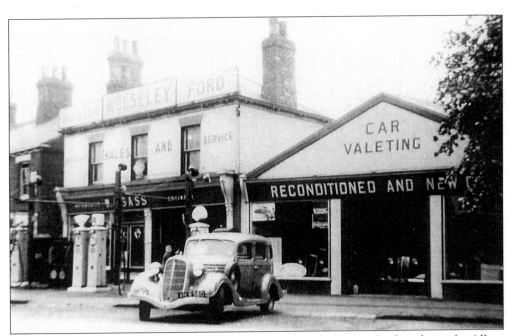

W.A. Sass automobile engineers in the late 1930s. Mr Sass had been chief mechanic for Allens in Bridge Street, and started his own business here in 1924. Known as the Monument Garage, it closed in 1983.

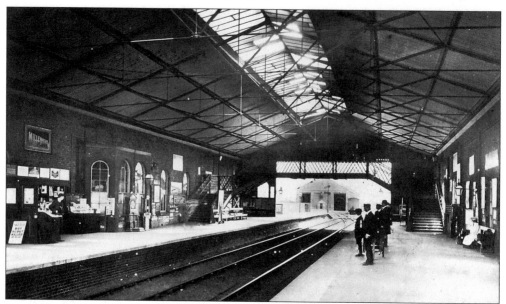

Brigg Railway Station, part of the Great Central Railway, looking towards Barnetby in 1909. Stephen Bowring was the station master. W.H. Smith, the newsagents, had a stall on the station which can be seen on the left. The station was opened 1 November 1848.

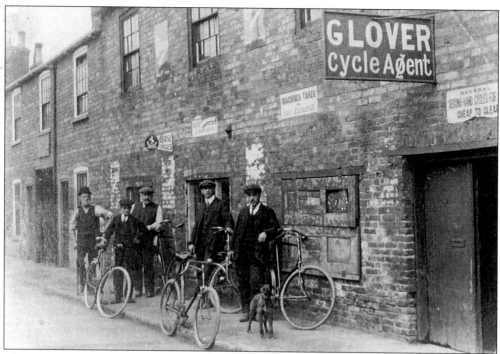

The rear of Walter 'Rammy' Glover's Wrawby Street shop. This is Garden Street, one of five new streets added to the town in the building boom of the 1850s. Cross Street was also one of the five. 'Rammy' Glover is the man in the middle of the group.

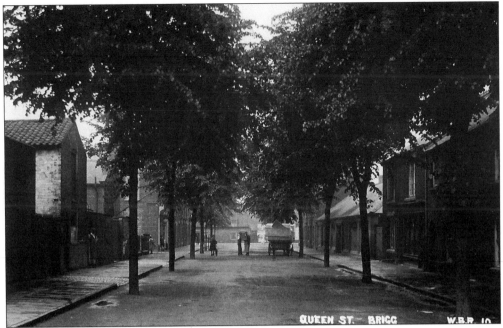

Queen Street, yet another new street of the 1850s named after Queen Victoria. In 1907, when this picture was taken, most of the property belonged to Sutton Bean's brewery.

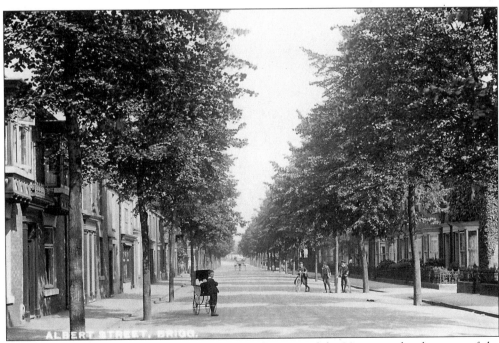

Albert Street, close to the railway station. Another part of the Victorian development of the eastern end of Brigg, along with Princes Street, all very loyal names!

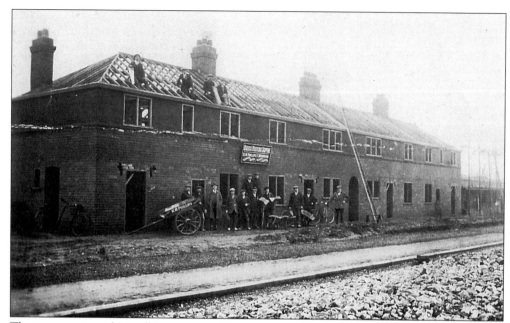

The construction of Woodbine Avenue. This was part of the Brigg Housing Scheme which was the first local authority housing scheme under the Local Authority Act, 1919. It was started in 1920, as a scheme to build better housing. The contractor was R.M. Phillips.

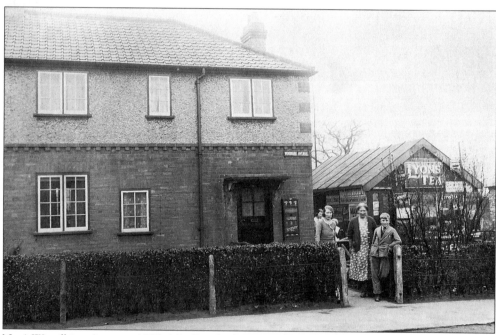

No.1 Woodbine Avenue, 1932. Mrs East had a general store and sub post office and she can be seen with some of her family at the gate. It was a busy shop opposite to Glebe Road School and served the newly built Woodbine Estate.

Three

Events

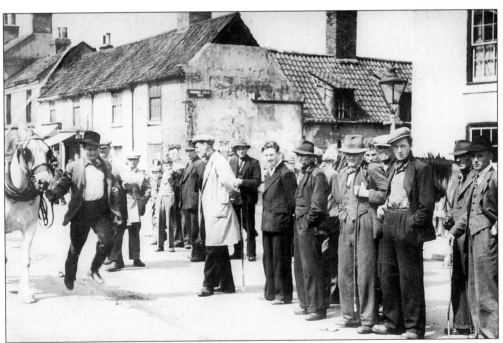

Brigg Fair. A typical scene at the annual horse fair outside the White Horse Hotel. Horses were sold by barter on the roadside. Many horse dealers descended on Brigg in the first week of August, but modern regulations took the horse sales away from Brigg streets to the auction ring.

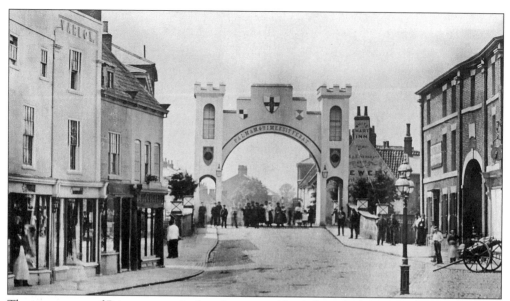

The importance of Brigg as an agricultural centre in North Lincolnshire is shown by the county show held in the town in 1880. This temporary archway was erected over the county bridge as part of the celebrations.

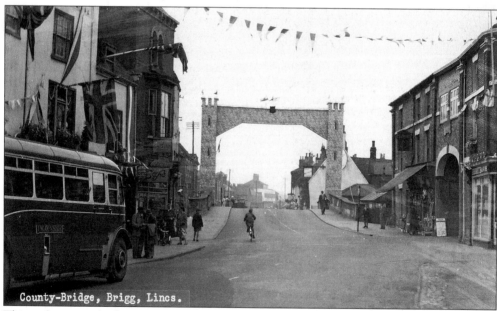

County-Bridge, Brigg, Lincs.

This archway was built to commemorate the coronation of Queen Elizabeth II in 1953. It was built by R.M. Phillips for the old established riverside firm of Spring and Co. Very little has changed in the seventy years between the two pictures on this page.

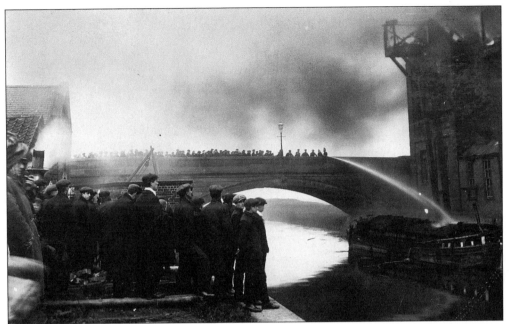

This huge fire at the Yarborough Oil Mills started on 22 May 1910. Crowds of local people went to watch from vantage points on the bridge and opposite river bank. The event was recorded by local photographers, Wilmore and Sons of No.5 Bridge Street.

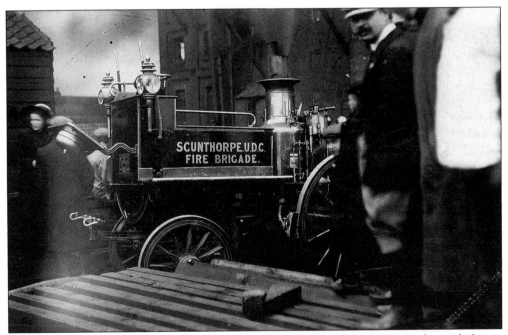

The intensity of the fire proved to be too much for Brigg's manual fire engine and more help was required. The Scunthorpe fire brigade with its steam engine was sent for. A further appeal for more help brought the Grimsby horse-drawn engine and tender.

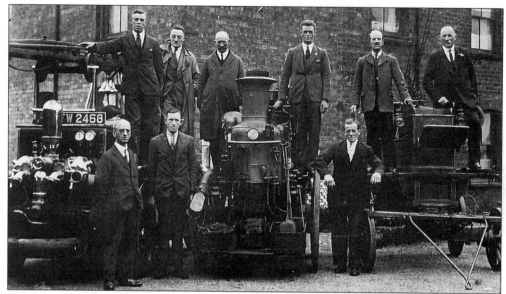

A new fire engine was eventually purchased in the mid 1930s, a new Merryweather seen on the left, replacing the old manual on the right. This picture was taken behind Spring's factory in the Council Yard with members of the brigade. In the picture are, back row, left to right: J. Maguire, ? Glover, ? Caudwell, S. Maguire, 'Prim' Watkin, F. Shemmings. Front Row, left to right: Dick Ashton, S. Cooney, H. Neall.

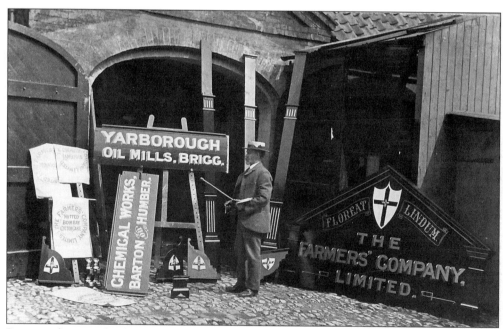

Painting the signs for the new Yarborough Oil Mills, is Mr C. Green, the signwriter. He had a shop at No.57 Wrawby Street, later to become the *Lincolnshire Times* Office.

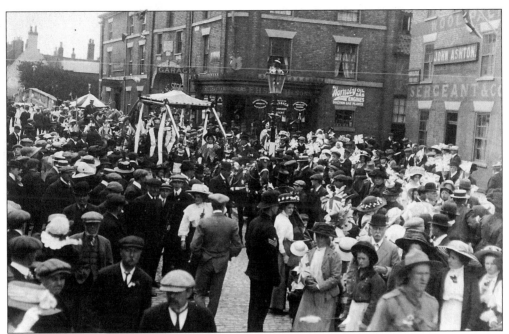

Celebrations of the Coronation of King George V in 1911. The procession is entering the Market Place from the county bridge with a lone police sergeant keeping his eyes on the crowds.

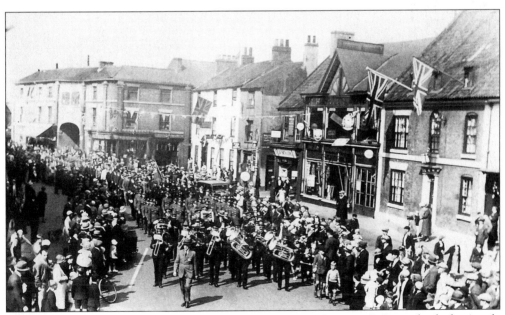

Celebrations for the Silver Jubilee of King George V in 1935. Major G. Pigott leads the parade through the Market Place.

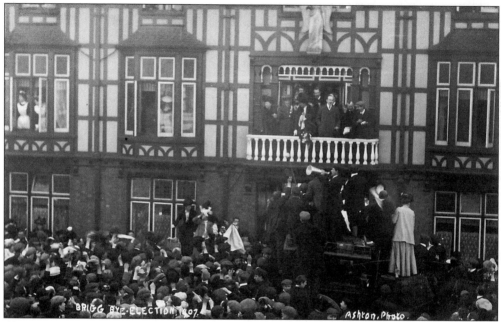

The Parliamentary by-election for the Brigg constituency, 1907. Sir Berkeley Sheffield was the successful Conservative candidate with a majority of 116. He can be seen with his band of speakers on the Angel Hotel balcony.

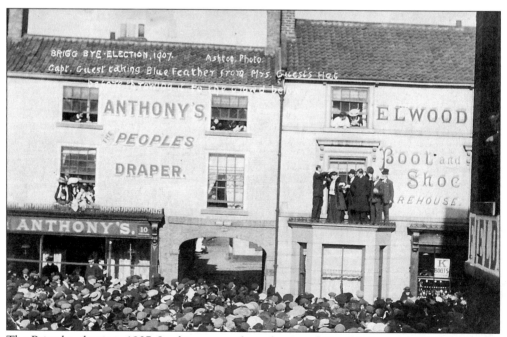

The Brigg by-election, 1907. Looking across from the Angel Hotel balcony, the defeated Hon. Frederick Guest (Liberal) and his party are shown on the ledge above the window of Elwood's Boot and Shoe shop. Crowds thronged the Market Place to hear the result.

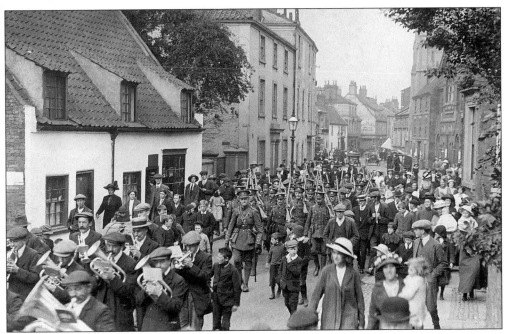

The Brigg Territorials depart on active service, 7 August 1914. This first batch of volunteers, led by the band, are marching past the Manor House, on their way to the railway station to leave for the war. They are joined by enthusiastic followers.

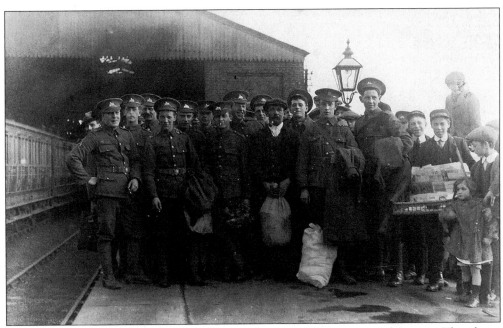

A final farewell, from Brigg Railway Station, for many young men of the town. They leave behind the newspaper boy from W.H. Smith.

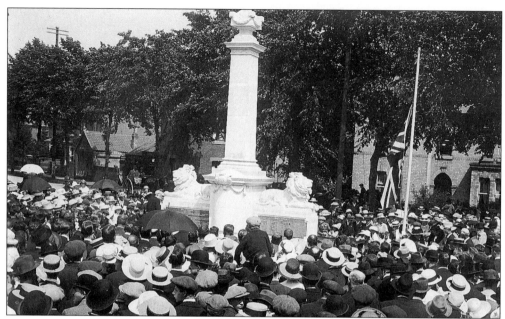

In the presence of a large crowd, the war memorial was unveiled by Mrs Stamp on Sunday 15 June 1919. The memorial was donated by her husband Councillor Harry Stamp.

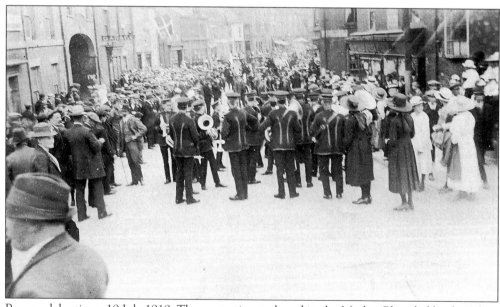

Peace celebrations, 19 July 1919. The procession gathered in the Market Place led by the Silver Band, demobilised soldiers, members of the council and inhabitants of the town and neighbourhood. A moving moment was when the procession made a halt at the recently unveiled memorial.

Four

Leisure

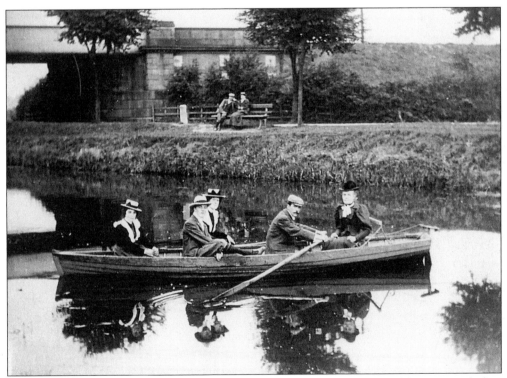

A Sunday afternoon on the river. A scene of days long gone by on the Old River Ancholme close to the railway bridge. Behind the couple on the bench is the road from Brigg to Cadney.

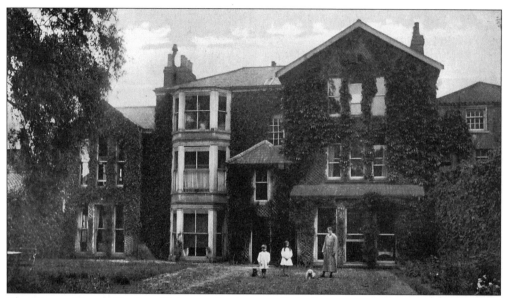

The Manor House Garden. This was the home of Mr Gervase and Lady Winifrede Elwes between 1889 and 1913. They established the North Lincolnshire Music and Drama Festival which was first held in the spring of 1900 at Brigg Corn Exchange. After the Elwes family left, it became the Manor House Convent school.

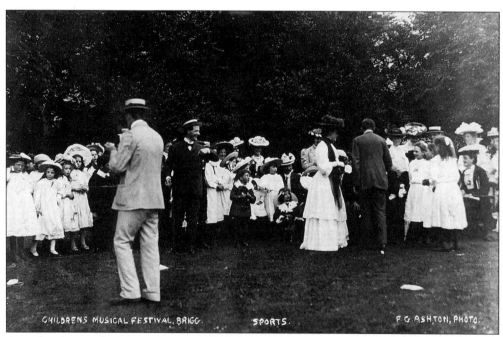

CHILDRENS MUSICAL FESTIVAL, BRIGG. SPORTS. F. G. ASHTON, PHOTO.

A garden fete at the Manor House, June 1906. Children enjoyed sports on part of the lawn. Lady Winifrede is dressed in white and beside her, with his back turned, is her brother the Hon. Fielding. Mr Gervase Elwes laughs at something as he pulls out his handkerchief.

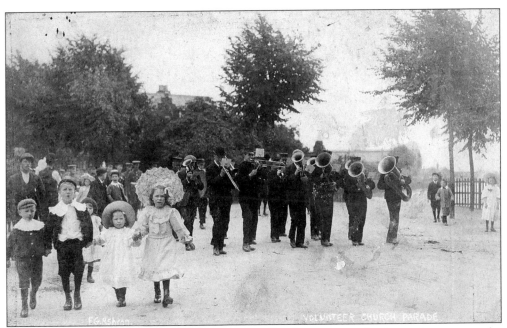

Volunteer church parade, May 1905. The Silver Band is just outside the station gates at the entrance to Station Road. In their Sunday best are the Rands children, Percy, Alf, Flo and Jessie. The band was formed in 1879, the antiquated instruments that were played were generously replaced in 1913 by Mr Gervase Elwes as a parting gift.

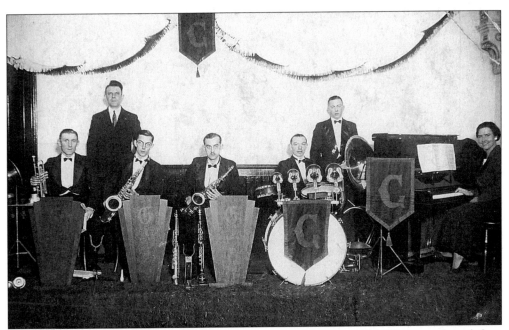

The Glanfordians, a popular Brigg dance band pictured here in 1934. They are, from left to right: Sandy Cairns, Bill France, Brian Glover, Stan Hogarth, Jimmy Lancaster, -?-, Mary France.

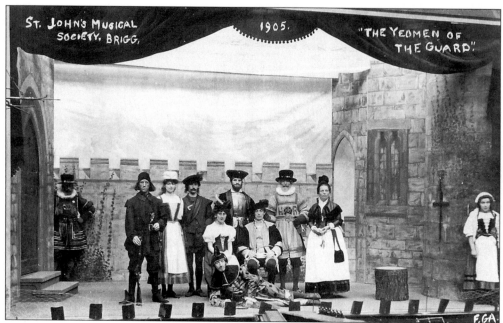

St John's Musical Society. A Brigg curate, the Revd Lambert, formed the society in 1900 using the church choir as a nucleus. Commencing 21 October 1905, the society gave five performances of the Gilbert & Sullivan operetta in the Corn Exchange, Brigg, to crowded and enthusiastic houses.

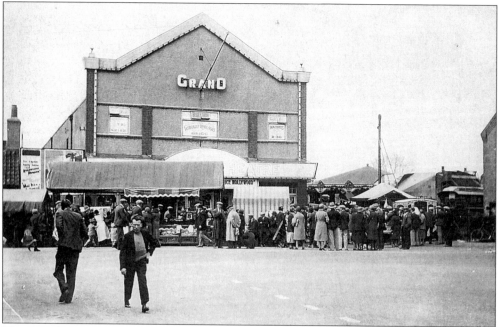

The Grand Cinema. It opened in 1928 and advertised itself as one of the smartest and most up to date theatres in Lincolnshire. The Grand had a seating capacity of 1,000. It stood in Wrawby Street near to the White Horse Hotel, and closed its doors in 1965. The annual May Statute Fair held on the White Horse Paddock was always very popular.

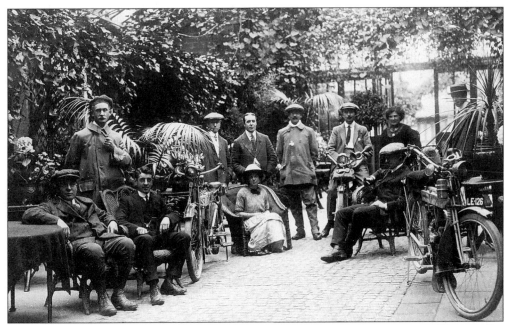

The Lincolnshire Motor Cycle Club, 1912. Motor cycling enthusiasts are seen here in the courtyard of the Angel Hotel.

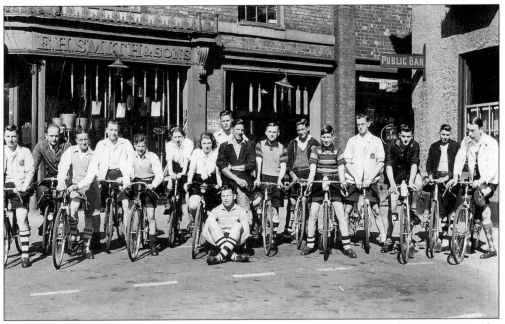

The Brigg Wheelers, a group of enthusiastic cyclists who met each Sunday morning in the 1930s at about 8 o'clock outside the Woolpack Hotel. They toured around the towns and villages averaging about fifty miles a day, arriving home about seven in the evening. The Wheelers disbanded when the Second World War started.

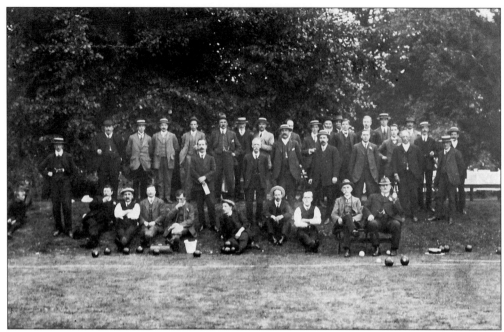

The Brigg Bowling Club, one of the oldest established clubs still in existence in the town. This group was pictured by Ashton in the early part of this century. The gentleman standing on the left of the back row wearing a flat cap is Mr Walter 'Rammy' Glover, owner of the cycle shop in Brigg at this time.

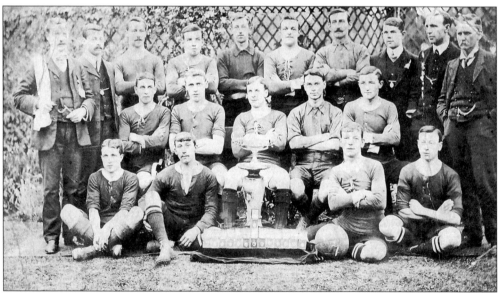

The Brigg Ancholme United Football Club. In the 1906/7 season the team won the Barton and District League, quite an achievement in those days, and made a name for itself in North Lincolnshire circles. Back row, left to right: Rands (trainer), Richardson (secretary), Beeston, Cleary, Miller, Scrivener (vice-captain), Walton, Kitchen, Wray (com.), Clark (com.). Middle row, left to right: Thompson, Bryan, Burdett (captain), Young, Horstead. Front row, left to right: Sunley, Holland, Dent, Moulds.

Five
Religion and Education

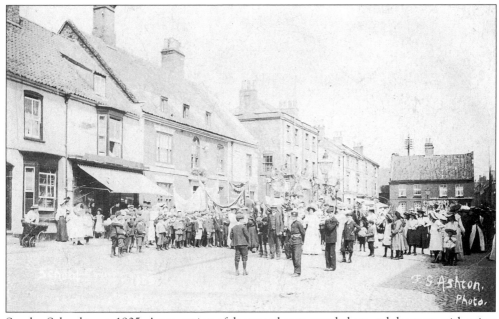

Sunday School treat, 1905. A procession of decorated carts paraded around the town with prizes awarded for the best one. The children had games in a field and tea in the school rooms, quite a highlight in August!

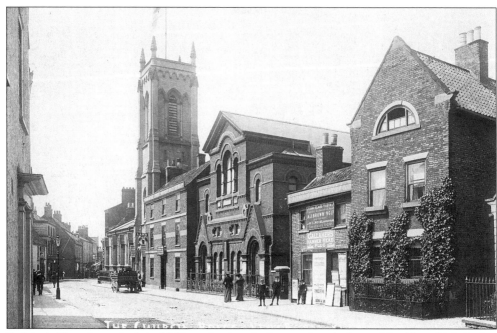

St John's Church was built in 1843 on the site of a former chapel of ease. The United Methodist church opened in 1865, but was pulled down in 1966.

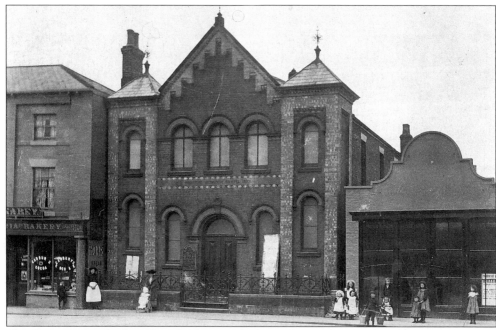

The Primitive Methodist Chapel. This was built on the south side of Bridge Street between Forrester Street and West Terrace. The foundation stone was laid in 1840, but alterations were made later to the building. It was locally known as the Bourne Methodist after Mr Hugh Bourne, a founder member.

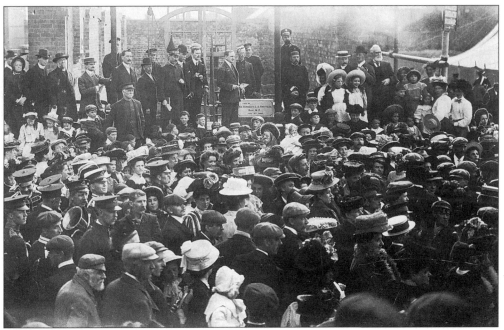

The Salvation Army. Sir Berkeley Sheffield MP, laying the foundation stone at the new Salvation Army Hall in West Terrace, 11 July 1908. The building is now used as a furniture warehouse.

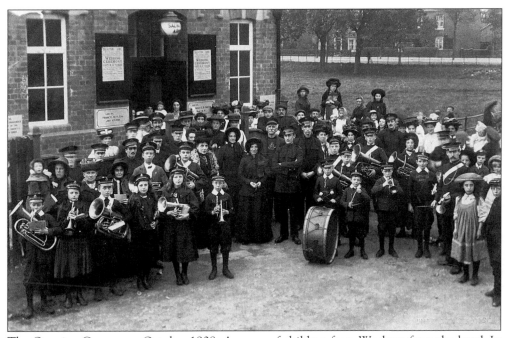

The Opening Ceremony, October 1908. A group of children from Worksop form the band. In the background is Bridge Street with houses on the far side only.

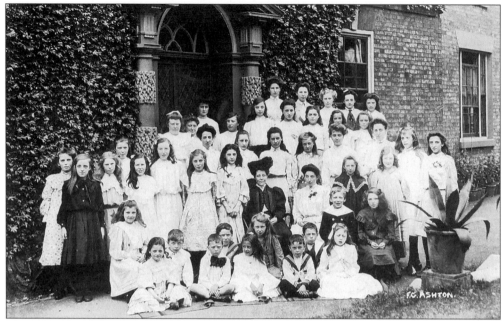

The Old House School. The principal was Mrs Percy Hawkridge, a certified teacher of Cambridge University, assisted by a fully qualified staff of mistresses. A school for the upper classes, it boasted spacious and 'healthy premises, and sanitation in perfect condition'! It closed in the early 1900s and is now the Exchange Hotel.

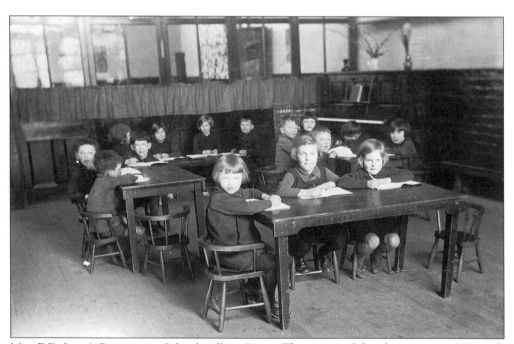

Miss E.D. Lyne's Preparatory School, Albert Street. This is one of the classrooms in 1930 with B. Quickfall, R. McLoy and E. Laverack sitting at the front table. It started in the building which formerly housed the National School and later moved to its present site in Bigby Street.

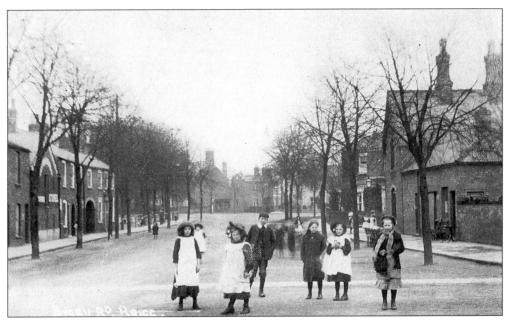

Boys and girls pose for the photographer close to the National School, *c.* 1909. The boys' side of the school was in Albert Street, the girls' in Bigby Road. The school was erected in 1855 for 185 children. The headmaster's house can be seen on the right. The head for many years was William Pawley.

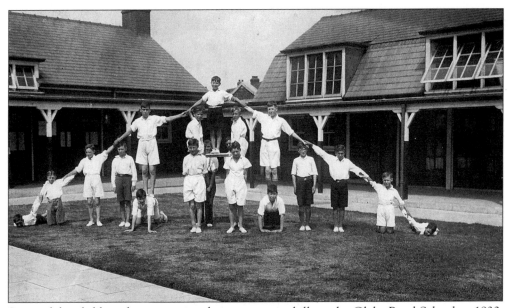

Some of the children demonstrating their gymnastic skills at the Glebe Road School, *c.* 1930. In 1929 children transferred from the National School to a new school in Glebe Road along with the headmaster, Mr E. Bratley, and his staff.

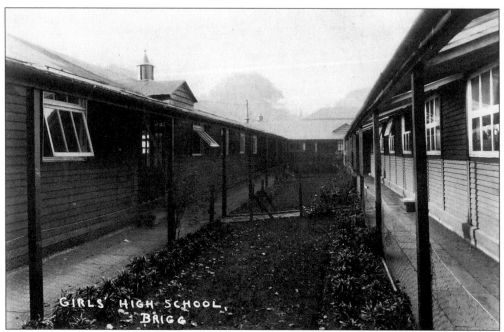

The Girls' High School which started in Bigby Street in 1919. Miss M. Lardelli was the headmistress. Initially it was comprised of three huts, making an arrangement of quadrangle and cloisters possible. The little bit of garden made all the difference! The school moved to a new site in 1936 on Wrawby Road.

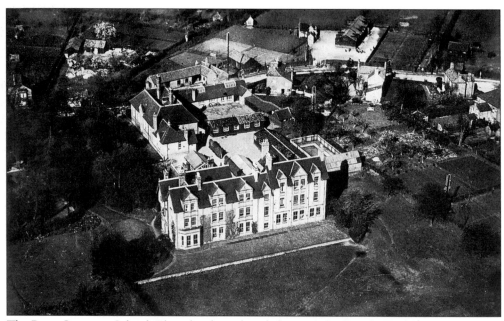

The Brigg Grammar School. The school was founded in 1669 by Sir John Nelthorpe of Scawby. This aerial picture shows the school buildings and grounds around 1930. The boarding house which was extended in 1911 for fifty four boarders is at the front. The old Brigg infants' school can be seen at the top right.

Six

Regeneration

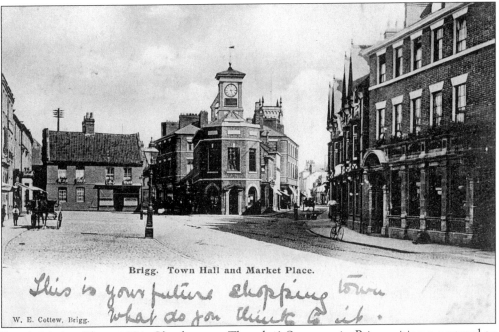

Brigg. Town Hall and Market Place.

This is your future shopping town what do you think of it.

W. E. Cottew, Brigg.

Brigg's Market Place, 1904. Clearly not a Thursday! Someone in Brigg writing a postcard to Spilsby raised the question of Brigg as a future shopping town and this has become pertinent again ninety years later.

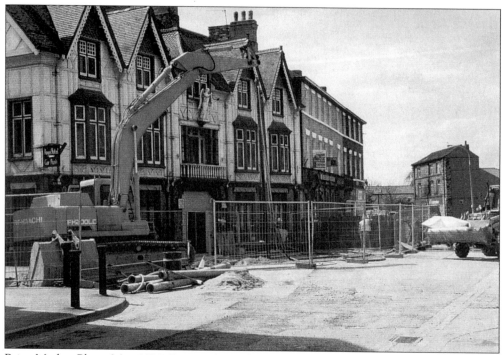

Brigg Market Place, May 1993. During the pedestrianisation of Brigg's centre new sewers were laid.

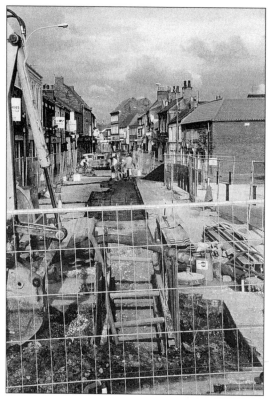

More Victorian sewers being replaced in Wrawby Street, May 1993.

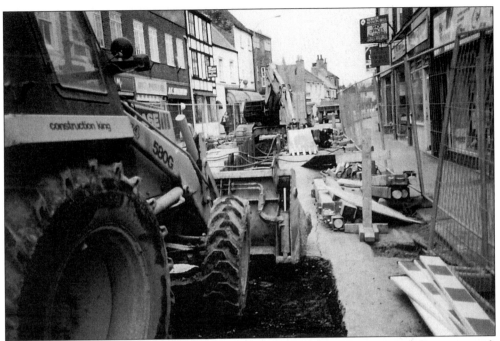

Wrawby Street, May 1993. Much heavy machinery and barriers are in evidence as work continues to leave this part of Wrawby Street free for pedestrians.

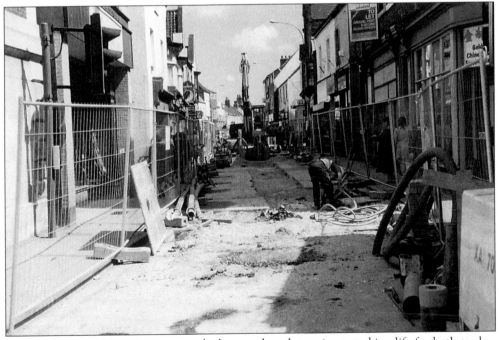

Wrawby Street, July 1993. Two months later and work continues making life for both traders and shoppers difficult.

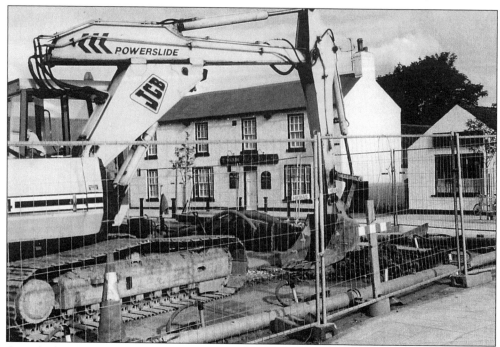

Outside the White Horse Hotel, Wrawby Street, July 1993. The pipe laying nears completion at the corner of Queen Street and Wrawby Street and soon the town will benefit from the upheavals.

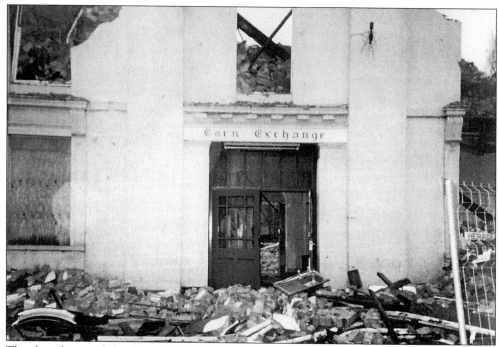

The demolition of the Corn Exchange. The building was erected in 1850 and, after several public meetings, demolished in 1995. The townsfolk were sad to see it go for it had served numerous local organisations as an all purpose hall.

Seven
Wrawby, Barnetby and Bigby

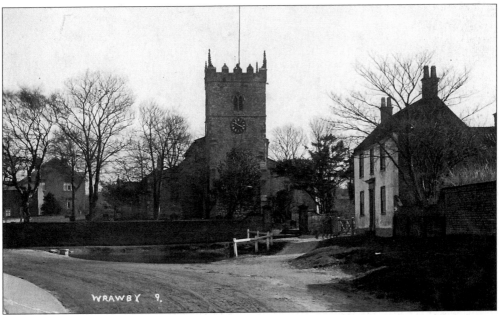

WRAWBY 9.

A peaceful view of the pond in the centre of Wrawby village, with the church of St Mary as a central feature, *c*. 1920. Pond House to the right was a farmhouse and still has farmland today. Soon after the Second World War the pond was filled in and the area is now a tarmac area used mainly as a car park for people going to the church.

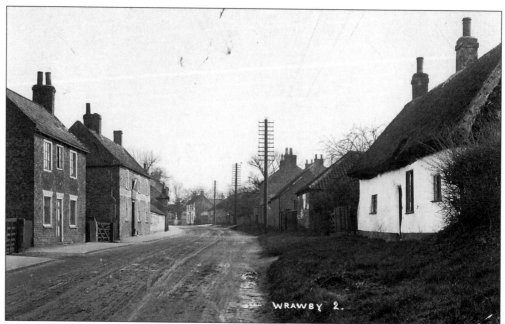

Brigg Road, Wrawby. The thatched cottage on the right was one of several in the village, but has been demolished along with most of the buildings in this picture, all replaced by new housing. The second building on the left remains, a public house now known as the Jolly Miller, but is here the White Horse, selling Sergeant's Brigg Ales.

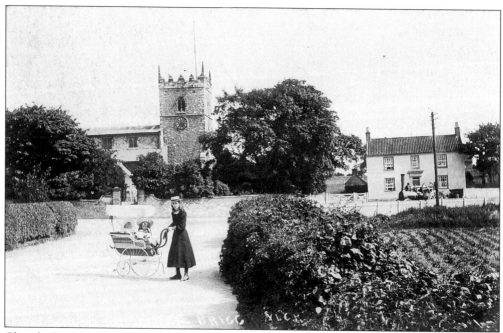

Church Corner, Wrawby, *c.* 1905. A young lady with her two charges poses for the photographer in Vicarage Road. A traction engine can be seen in front of Pond House taking water from the village pond, a regular sight at that time. The garden to the right has changed very little and still belongs to the Gillatt family.

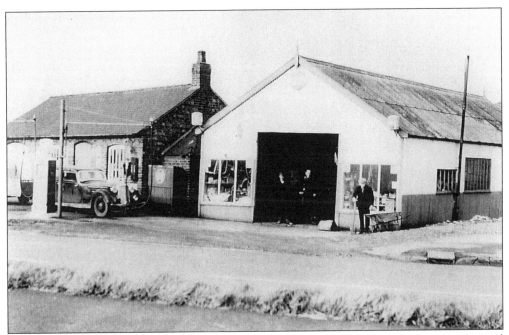

The Blacksmith's Shop and Garage in the 1950s. A modern garage with forecourt and petrol pumps now stands in place of these buildings. On Brigg Fair Day as many as thirty horses would be shod starting at six o'clock in the morning. In front of the garage are 'Tanner' Harris, Charles Gillatt, the owner, and Robert Andrew.

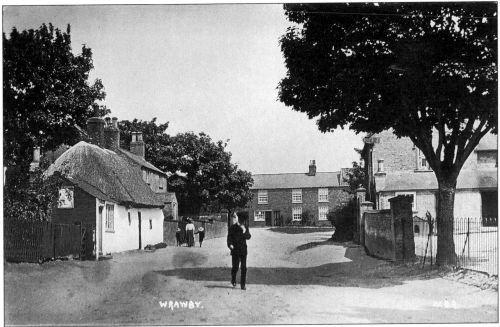

Vicarage Road, Wrawby, c. 1913. The old school on the right, built in 1842, has recently been converted to a private residence with a bungalow built on the playground. Bungalows have also replaced the thatched cottage opposite. When Walter Robinson took this photograph the post office was in the facing buildings.

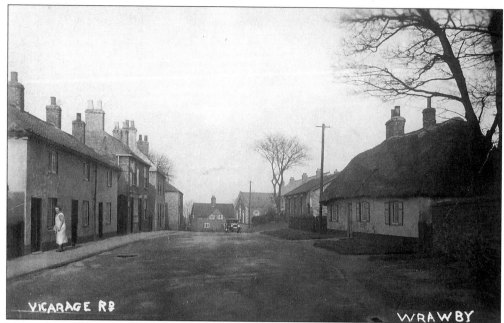

Vicarage Road, Wrawby, *c.* 1930. The thatched cottage is long gone and the parish hall next to it is now a bungalow. The cottages on the extreme left have also been demolished and a bungalow built in their place. The shop further down is the only remaining shop in the village, now the post office and general store. On the far right is the Wesleyan chapel built in 1885 and still in use.

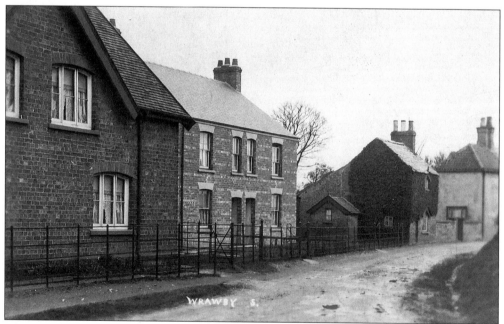

Chapel Lane, Wrawby. Named after the chapel on the corner of the lane at its junction with Vicarage Road and seen in the previous picture. The lane looks remarkably similar today. There were two chapels in the village, the other, a Primitive Methodist, was built in 1912 on Brigg Road.

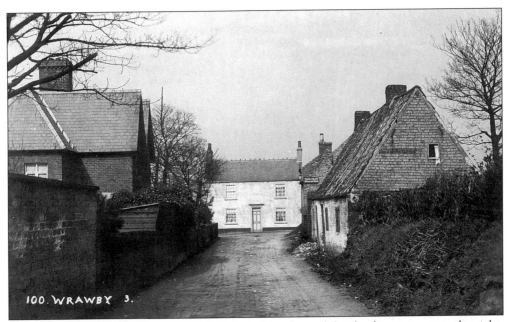

100. WRAWBY 3.

Little Lane, Wrawby. New properties now stand in place of the derelict cottage on the right. Next was the parish reading room, known as Taplings Reading Room, so named because of an annual sum of two pounds ten shillings left by T. Tapling Esq. to support it.

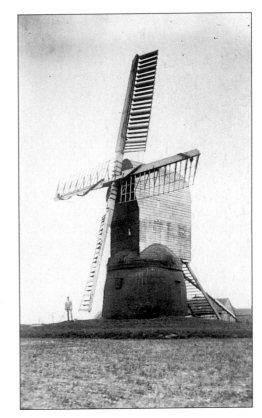

Wrawby Mill. An early picture of this mill built in the eighteenth century and worked by wind until 1939. It originally had two hand clothed sails and two spring sails. The hand clothed sails were removed in 1916 and replaced by spring sails from Laceby five sail mill. The last post mill to survive in Lincolnshire, it was restored in 1960 and is now open to the public on certain weekends.

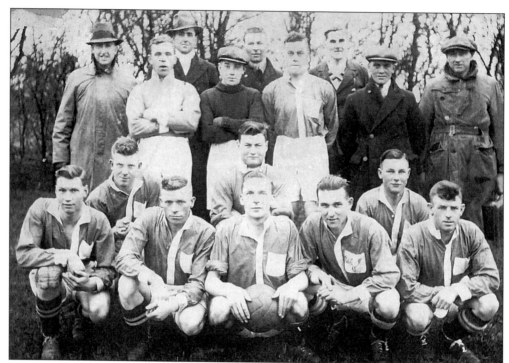

Wrawby Football Club, 1935. The team played in the West Wold League on a pitch on Tunnel Road. Pictured in their new kit are, standing, left to right: Ron Etty, Bill Wilson, ? Lingard, Gordon Wraith, ? Lingard, George Watson, Bill Denton, George Willerton, Bill Etty. At the front, left to right: Fred Parkin, Jack Taylor, Jeff Havercroft, George Beedham, George East, Sid Smith, Henry Holland, Archie Havercroft.

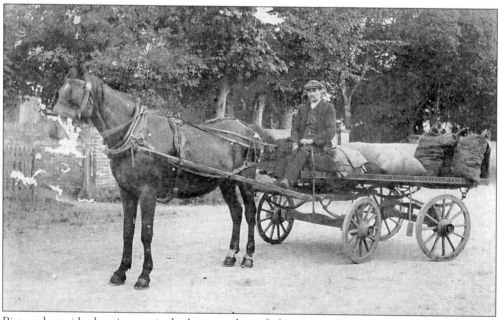

Pictured outside the vicarage is the horse and cart belonging to Fred Taylor, coal merchant, of Wrawby. The coal was stored at Elsham Station but Fred lived on Barton Road.

The Black Horse, Wrawby, 1934. This building replaced an earlier thatched house and sold Tower Ales of Tadcaster Tower Brewery. The licensees Percy and Alice Gilliatt stand in the doorway as Mr Taylor of Sturton shows off his travelling entire (stallion). Albert Lancaster, the butcher, is standing near his van.

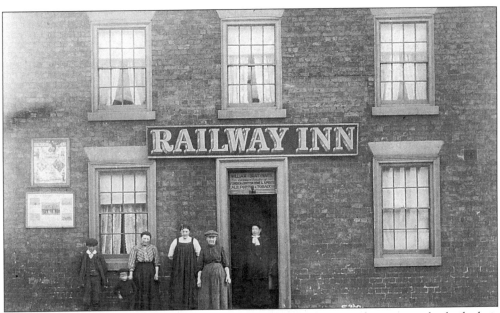

The Railway Inn, Barnetby, 1914. Truswells of Sheffield, who were the owners, also built their own malt kilns in the village. Local farmers could bring their barley, and after processing, it went by rail to Sheffield to be brewed. William Braithwaite was landlord from 1904 to 1914; his wife can be seen here with other members of the family.

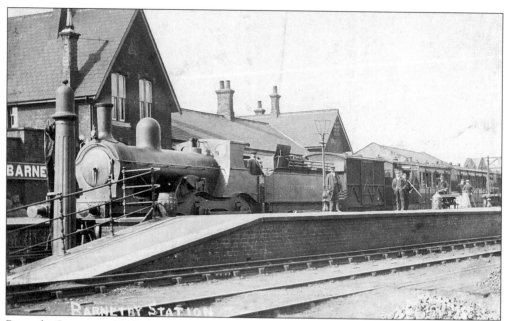

Barnetby Station, *c.* 1907. A passenger train is at the original island platform which catered for trains travelling from Grimsby until the station was reconstructed in 1912. The station buildings are in the background.

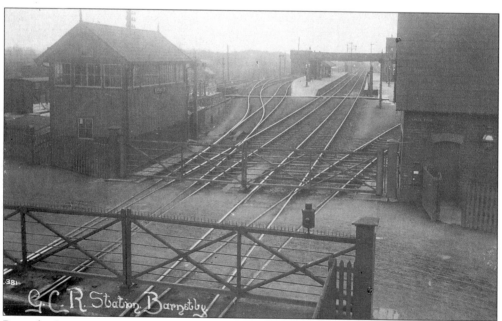

Barnetby Station, *c.* 1910. With the large increase in rail-borne traffic that would be generated with the opening of Immingham docks, it was necessary to quadruple the tracks in 1912. The railway crossing was replaced by a bridge with a subway. The east signal box seen on the left was repositioned.

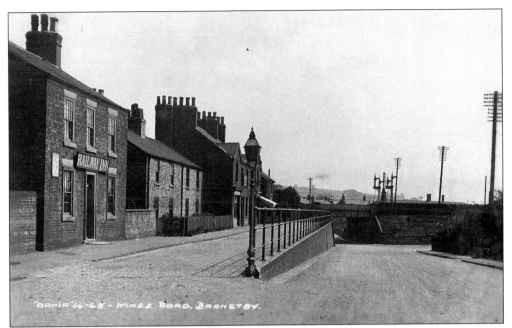

Kings Road, Barnetby. The original level of the road can been seen outside the Railway Inn, also the new road, subway and overbridge which were constructed when the improvements to the railway were made.

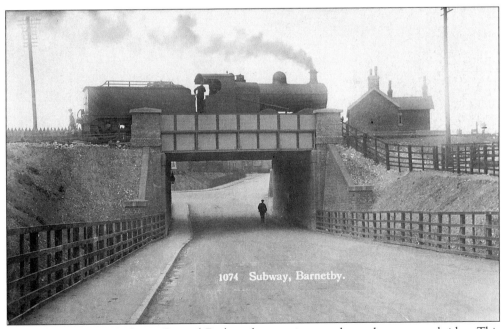

The Subway, 1914. A Great Central Railway locomotive stands on the new overbridge. This view is looking towards Kings Road and the malt kiln manager's house is on the right.

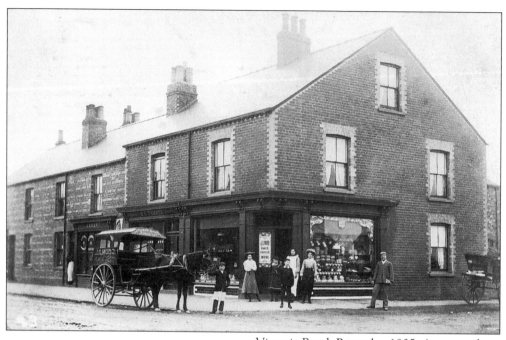

Victoria Road, Barnetby, 1905. A group of people pose for the photographer outside Johnny Mudd's corner shop. Perhaps his horse and cart is about to make a delivery of bread which was baked in the Hygiene Bakery behind the shop in Silver Street. The watchmaker's shop belonging to W. Turner, was next door and beside that was Catleys, where you could buy anything from buttons and bootlaces to medicines.

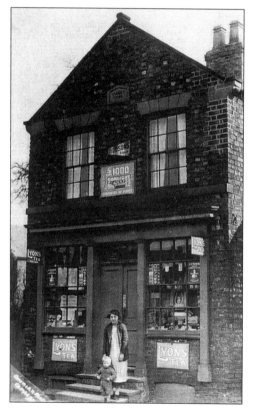

West Street, Barnetby. This is the first building on the left on entering West Street from St Barnabas Road and has the inscription 'W. Abey 1783' on its end. At the time this picture was taken it belonged to John Cox, the grocer, who was also the proprietor of an omnibus which went to Brigg on Thursdays.

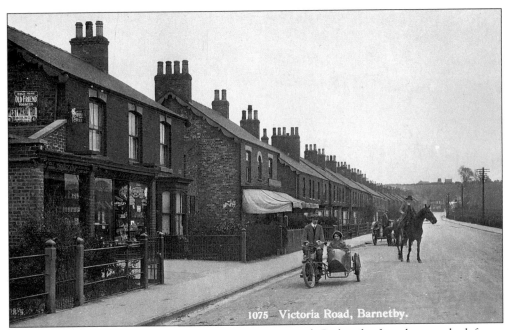

1075 Victoria Road, Barnetby.

Victoria Road, Barnetby. Looking from the subway towards Bigby, the first shop on the left was a general store and also an agency for cycles. In later years, accumulators were charged in a building behind the premises. It is now a private house. The blinds are pulled down to shade the Co-op shop almost next door.

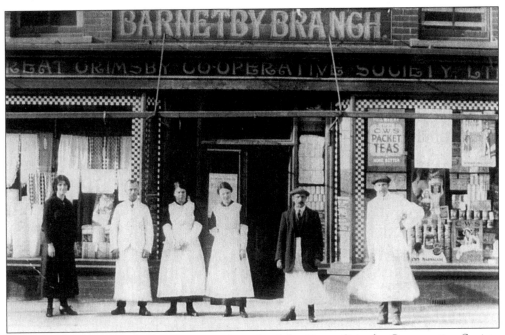

Barnetby Co-operative Store. This was a branch of the Great Grimsby Co-operative Society selling drapery to the left of the shop and groceries on the right. The photograph dates from just before the First World War when Mr Farmery was the manager. Mrs S. Braithwaite is third from the left.

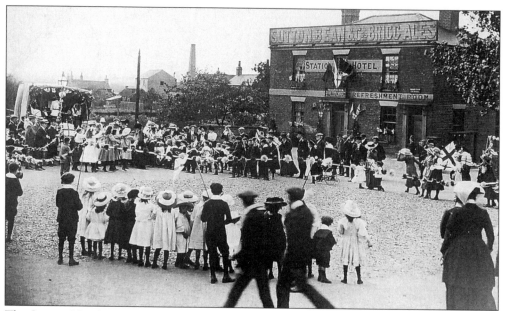

The Station Hotel, 1911. Owned by Sutton Bean of Brigg, the hotel stands in the forecourt of the station. Villages are celebrating the coronation of George V. The chimney to the left of the hotel was part of Stringfellow's mill which was driven by steam.

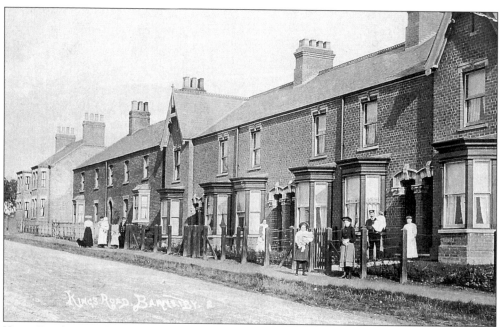

Kings Road, Barnetby, 1906. These houses were some of the first houses built on the left of Kings Road coming into the village from Wrawby, on the site of the old cattle market. They were mainly occupied by railway workers. Opposite was the market field which was also eventually built on.

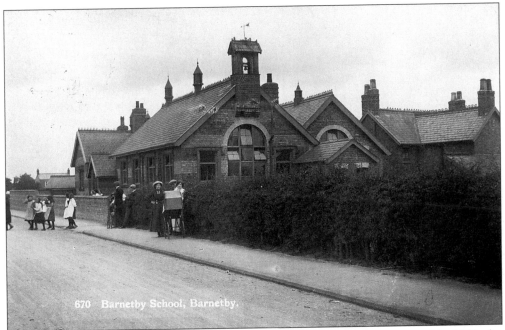

Barnetby School, *c.* 1916. Situated in St Barnabas Road, the school was erected in 1862. An infants' school was added in 1876, a girls' school in 1877 and it was enlarged again in 1905. A new school has recently been built on adjoining land and these buildings have now been converted into flats.

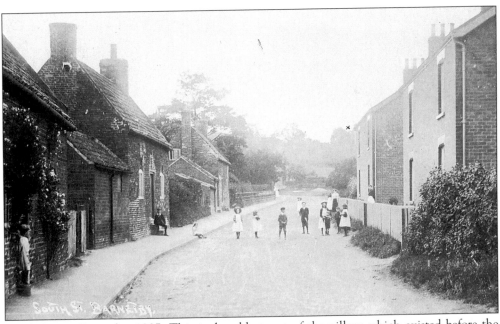

South Street, Barnetby, 1907. This is the oldest part of the village which existed before the coming of the railway. The cottages were most probably occupied by farm workers. Those on the left were demolished between the two wars and replaced with council housing.

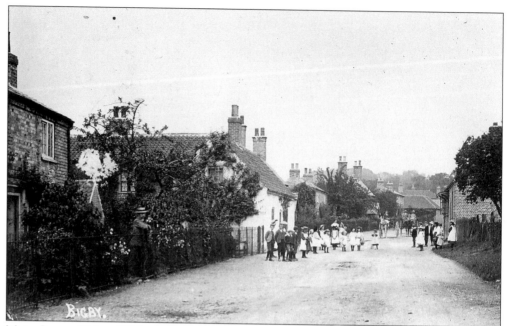

Main Street, Bigby, 1906. A group of children outside the school make this scene special. Looking towards Barnetby, the school building on the right has been replaced by two bungalows. The white cottage on the left was the post office, but as in most small villages, this facility is no longer available.

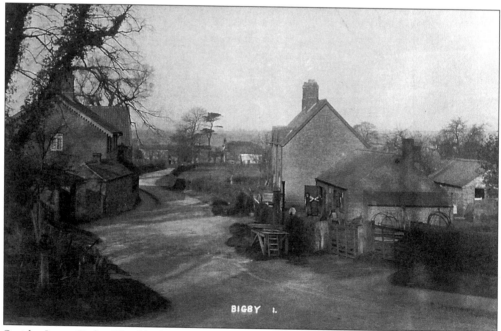

Smithy Lane, Bigby. The blacksmith's shop is first on the right in the picture with the village pump in front, on the lane. The open shed on the opposite side was used by the blacksmith as a store. It was later altered to become the village's general store, but has now closed.

Eight
Cadney, Howsham, Grasby, Searby and North Kelsey

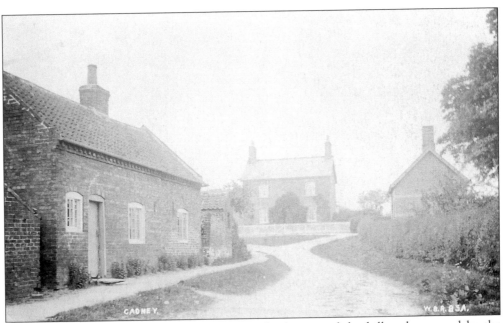

Pump Hill, Cadney. The village pump was at the bottom of the hill and was used by the villagers for all their water until mains water arrived in about 1950. The house facing the camera is The Laurels, situated on Vicarage Road and still a working farm.

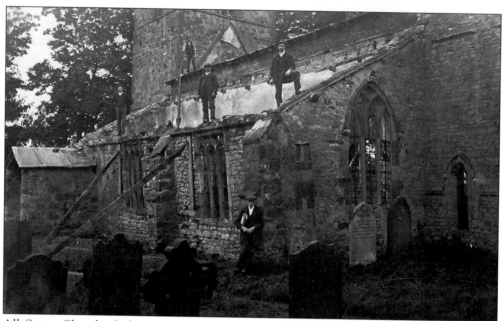

All Saints Church, Cadney. A very old church which was restored and then reopened for services 4 June 1913. It is still in use and the services are conducted by the vicar of Brigg. Here we see restoration work in progress.

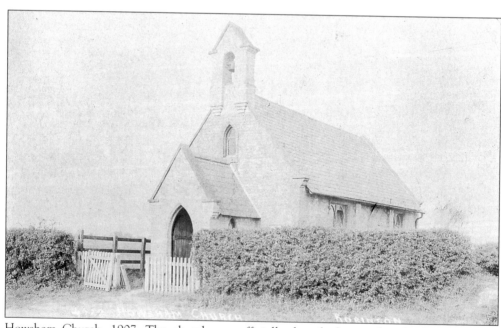

Howsham Church, 1907. The church was officially described as a chapel of ease and the services were conducted by the vicar of Cadney. Since becoming redundant it has been converted to a house.

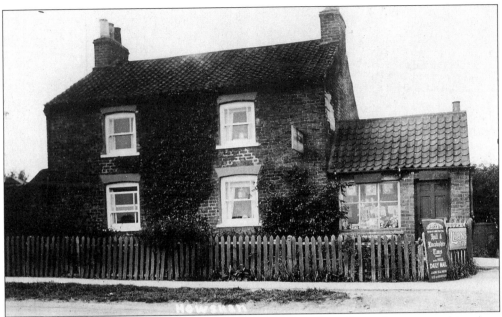

Main Street, Howsham, *c.* 1934. This is the first house in the village when approaching from Brigg. The little shop sold newspapers and groceries. An advertising board for the *Lincolnshire Times* is on the fence, although the shop had been closed for many years.

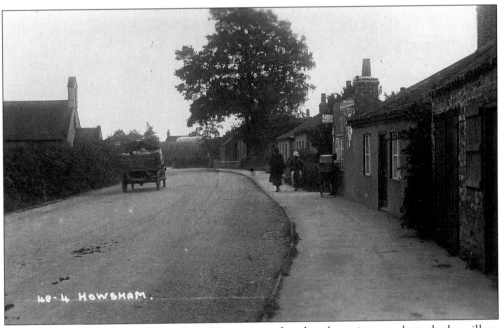

Main Street, Howsham. A lorry from Brigg passes the church on its way through the village towards North Kelsey. The pram is outside Herbert Wall's shop where you could buy cigarettes, paraffin and a few groceries. There are no shops remaining in the village today.

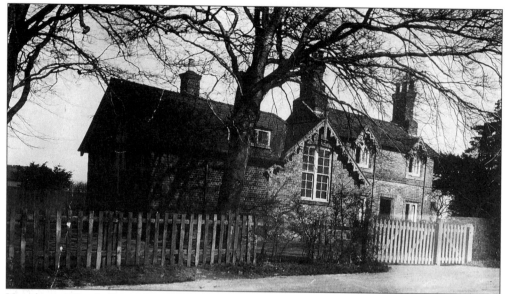

Howsham School. Erected in 1847 on Cadney Road, by the third Earl of Yarborough, it accommodated eighty six children from Howsham and Cadney. The master's house was attached and is now a private dwelling. The schoolrooms are used by the current owners to manufacture oak furniture.

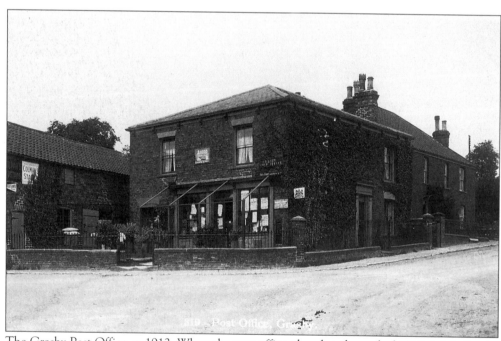

The Grasby Post Office, c. 1912. When the post office closed at the end of 1995, it left Grasby without a shop in the village. Mr Sidney Sumner, the postmaster when this picture was taken, also sold groceries, drapery and paraffin. Thursday was early closing day, when many people went to Brigg Market by carrier cart.

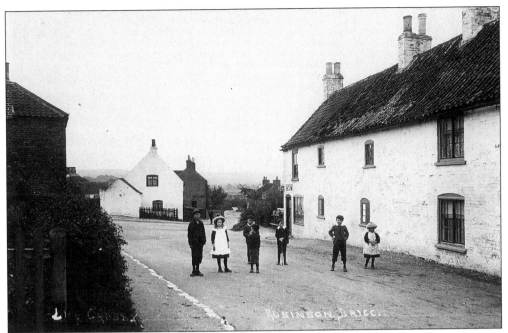

Vicarage Lane, Grasby, 1908. There was no traffic to worry these children standing in the road near Mrs Lacey's sweet shop, which later became a reading room. In the 1960s the white cottage facing was badly damaged by fire and had to be pulled down. A new bungalow was built on the site ten years later.

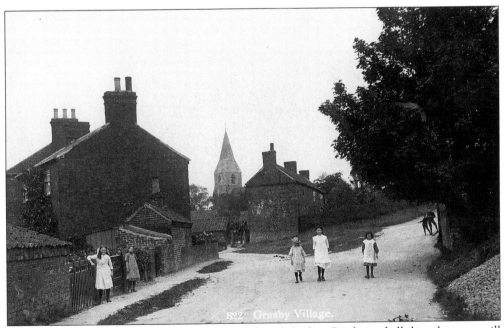

Clixby Lane, Grasby. Few buildings have been demolished in Grasby and all those here are still standing. Unfortunately the church spire no longer remains, it was removed in 1957 when thought to be unsafe. The church, All Saints, was rebuilt in 1869 paid for by the vicar Charles Tennyson Turner, brother of the poet Lord Tennyson.

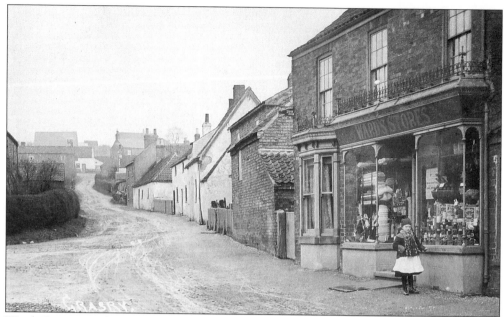

Wards Stores, Grasby. This general store in Front Street and an impressive shop front closed in the 1970s after ending its life as a butchers shop. Walt Turner's farm was on the corner where you could take your milk can to be filled each day. The low white cottage is no longer standing, but the other one has been expertly restored.

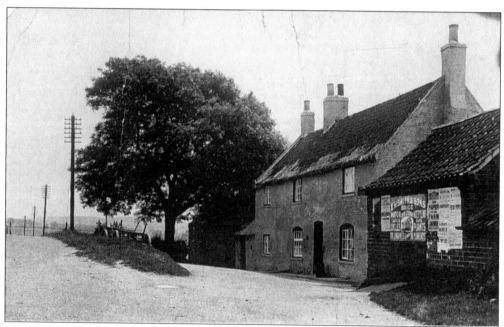

The Cross Keys, Grasby. This public house has been a focal point for more than a hundred and fifty years. In 1792 a licence was bought by the vicar Tennyson Turner to improve the sobriety of the population of the village. He installed a new landlord with instructions to keep the parishioners sober! The present landlord provides meals in a newly extended dining area.

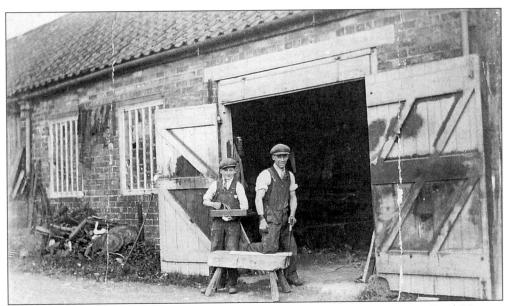

The Carpenter's Shop, Grasby. Jim Frankish is busy at work with his apprentice, Frank Haw, in the carpenter's shop on Front Street. Wheels and carts were made, but gradually less work was done here and more at Limber, where the family had another business. It closed in the 1970s.

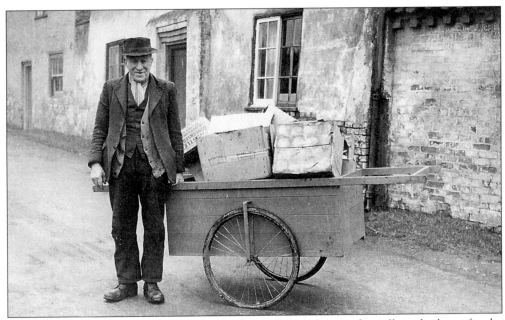

Jimmy Foster was a local preacher for sixty years. During the war, he collected salvage for the war effort. He is photographed in front of the mud and stud cottage on Front Street where he lived, which has now been restored. A farm worker, he was strictly teetotal.

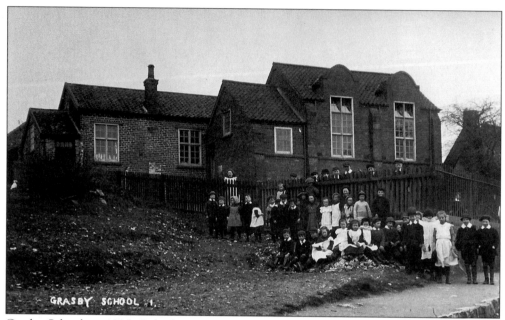

Grasby School, *c.* 1905. Rebuilt in 1855 and enlarged in 1897 for one hundred and forty children. Mr Westcott was the headmaster, a very strict disciplinarian, and his wife was an assistant. A Church of England school, it was altered again approximately five years ago, with an extension to provide indoor toilets and further classrooms.

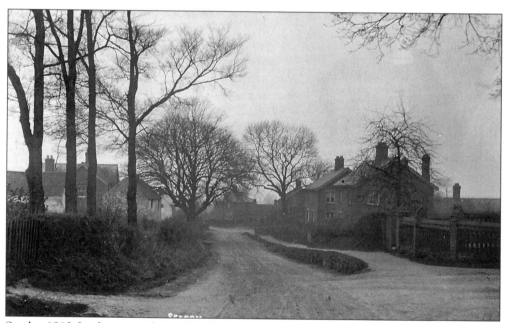

Searby, 1913. Looking into this secluded village, the footpath to Grasby can be seen to the front left, a part of the Viking Way. The village pump is in the distance on the right and was in use until mains water was provided in the 1930s.

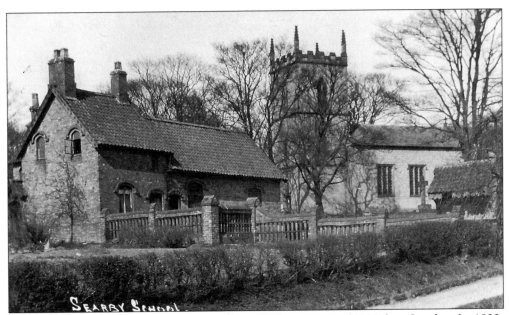

Searby School. The National School was built in 1854 at a cost of £200, but closed in the 1920s when the children were transferred to Grasby. The schoolroom is now used as the village hall and the school house is a private residence. Close by is the church of St Nicholas built in 1833.

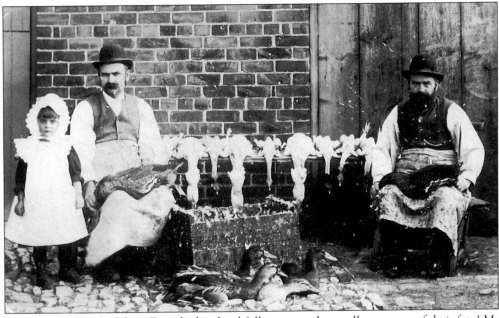

Pond House, North Kelsey. Four ducks, thankfully, seem to be totally unaware of their fate! Mr Tom Topliss, a poultry dealer, is pictured with his daughter and brother at his house in Carr Lane, preparing birds for market. He also had a carriers business to Brigg on Thursdays.

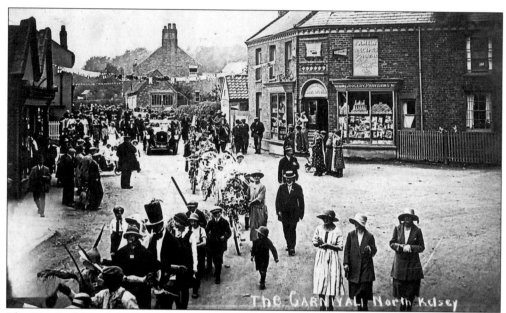

The Carnival, North Kelsey. This must have been a special event for North Kelsey people, but the authors have been unable to date it accurately. The village streets are decorated with flags, lots of people have turned out to watch the parade as it passes Cram's general store, a long established business, which has recently closed.

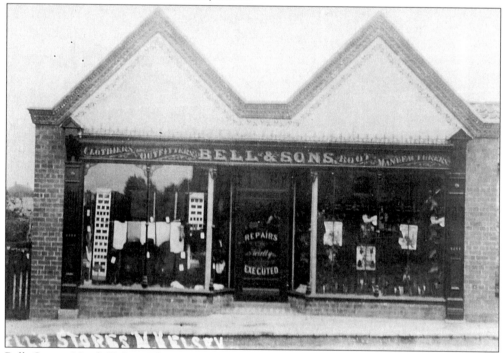

Bells Stores, North Kelsey. The stores are no longer to be seen on the Main Street since they closed after the Second World War and were later demolished following the death of the proprietor. Bell and Sons were boot manufacturers and clothiers with a cobbler's shop at the rear of the premises.

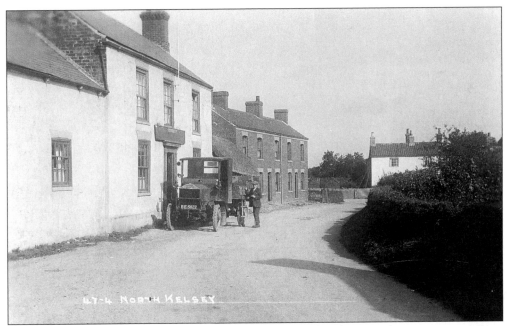

The Royal Oak, c. 1920. Francis Garretty was the landlord at the time this picture was taken. The Vimto advert on the lorry window suggests that the inn was about to receive a delivery of soft drinks.

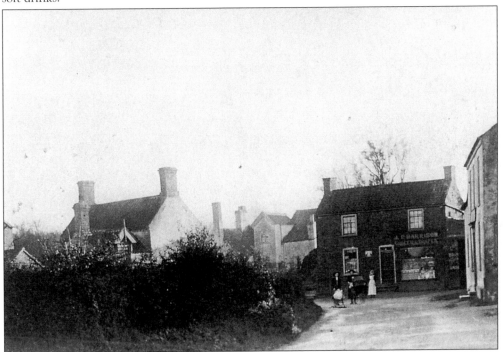

High Street, North Kelsey. The Royal Oak is on the right with another village shop facing it. Here J.P. Harrison had his grocery and drapery business. He also kept a carriers cart in a building to the right of the shop window, which is now a butcher's shop and post office. There is only one general store remaining in the village.

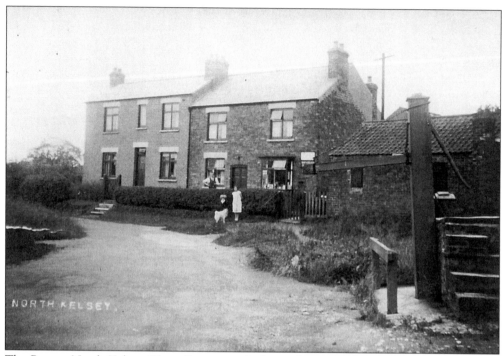

The Pumps, North Kelsey. The tall one was for horse-drawn 'tanks' which took the water to outlying farms, the smaller one, for domestic use. There was a metal cup attached to the pump by a chain for people to drink from. The house in the centre was the post office and sweet shop run by Mrs Emily Johnson.

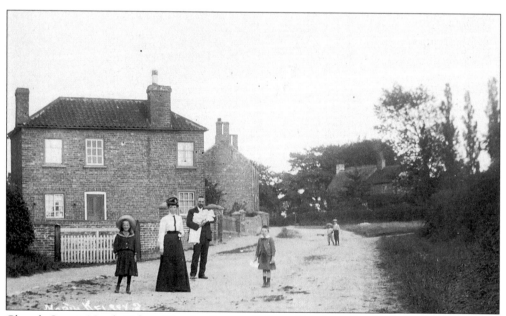

Church Street, North Kelsey. The family are all dressed in their Sunday best, perhaps for the baby's christening at the church of St Nicholas just out of the picture. Pinfold Farm is on the left and named after a pinfold across the road.

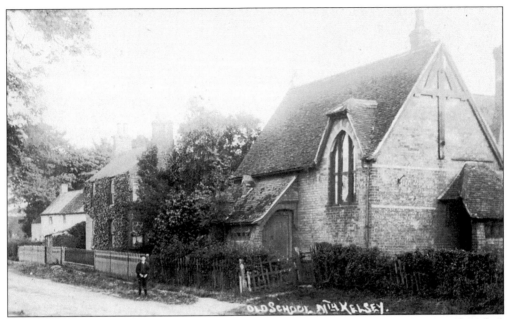

The Old School, North Kelsey. This was the original village school situated on South Kelsey corner. The building has been converted to a private house and is now unrecognisable. It has also been used as a village hall.

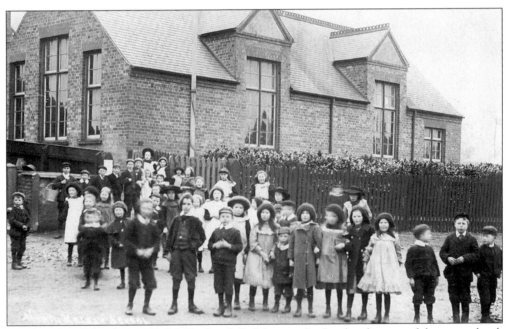

North Kelsey School, c. 1910. Mr Frederick Ralphs was the first headmaster of the new school, a council school built in 1896. He taught in the village for forty two years and retired in 1921. This school closed in the 1980s when a new school was built in Chapel Street.

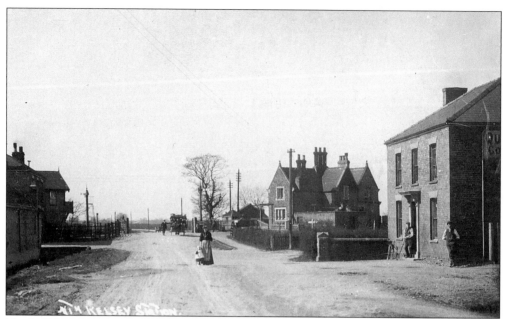

North Kelsey Station, 1905. The station was situated two miles away at North Kelsey Moor on the Barnetby to Lincoln line but has been closed for some time. Looking towards North Kelsey, the Queen's Head public house can be seen on the right; the licensee, at the time of the photograph was George Atkinson.

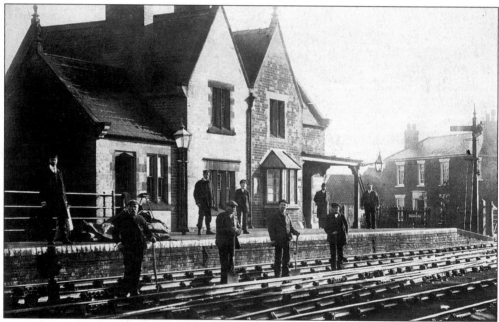

The railway was a boon to the small community. Coal and other commodities were stored at the station to be sold in the village. Milk, corn and straw was sent by farmers to the towns, providing jobs for local people. The station master, Alfred Hibbes and his staff together with the workers on the line are pictured in front of the station buildings which have been made into a private house.

Nine

Elsham, Worlaby and Bonby

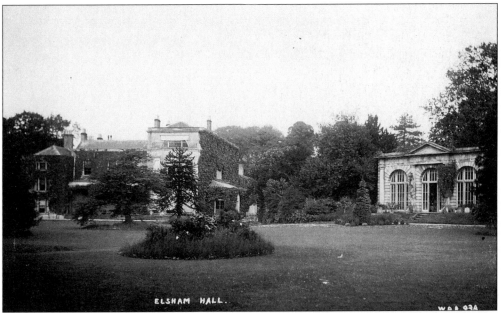

ELSHAM HALL.

Elsham Hall, *c.* 1912. This mansion of brick was built in the seventeenth century and stood in a park of one hundred and fifty acres, it was the home of Sir Francis Astley Corbett, the principal landowner in Elsham and Worlaby. The orangery, on the right, was filled with tropical plants. It is now owned by Capt. Jeremy Elwes, grandson of Mr Gervase Elwes and Lady Winifrede of Brigg Manor House.

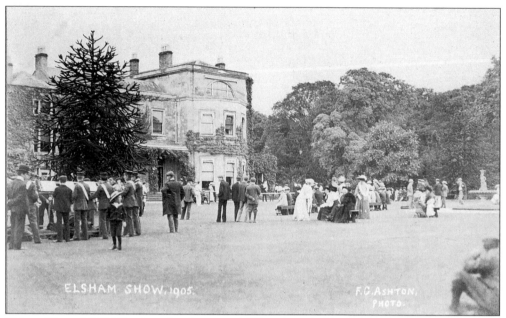

Elsham Show, 1905. The show first began in 1870 and was held on August Bank Holiday in the grounds of Elsham Hall. Flowers and vegetables were exhibited in marquees and sports competitions were held in the park, with water sports on the lake. It was a big day for Elsham people, families reunited here, rather like at Christmas, but notice was given that any person obtaining entrance without payment or misbehaving, would be ducked in the pond! The show ceased in the 1920s.

Hall Lane, Elsham, 1920. The house, first left, was occupied by the steward of the estate, Mr Frederick Stone. He was the last steward of the estate which included Worlaby and was responsible for taking on labour and collecting the rents, as well as other duties. It was the home of Tony Jacklin, the golfer, in the 1970s.

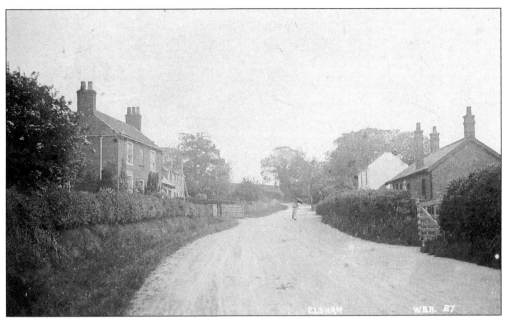

Barnetby Lane, Elsham, a pleasant tranquil scene on a sunny day, *c*. 1909. Shading herself with a parasol, a lady passes the blacksmith's house. His smithy is first right. On the opposite side is the joiner's shop and house.

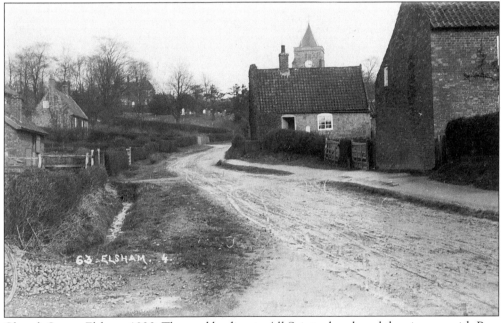

Church Street, Elsham, 1920. The road leading to All Saints church and the vicarage with Pear Tree Farm on the right. The next little cottage was occupied by a man who worked in the woods, but this has been pulled down. The dyke on the left has now been culverted and only the far building remains today. Attractive residences have taken their place.

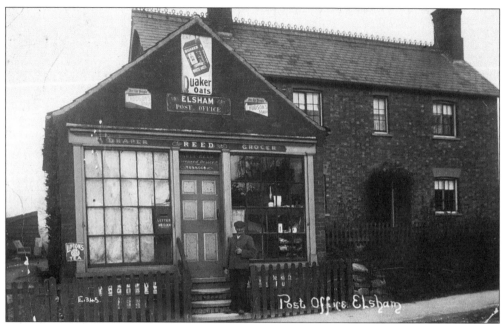

Elsham Post Office, 1912. Situated in Front Street, the shop looked just like this until five years ago, although the post office had moved some years before. Mr Jabez Reed was then the postmaster and a tireless worker for the chapel. He sold almost everything, sweets, tobacco, newspapers and ground his own coffee. He was succeeded by two generations of the Etty family.

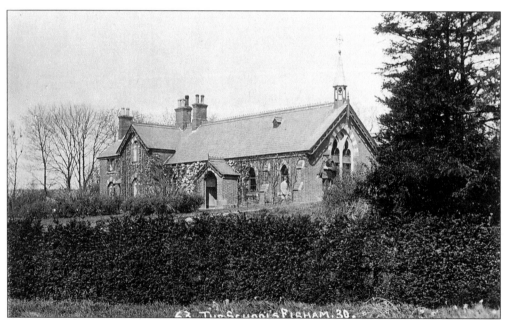

Elsham School, 1920. A public elementary school built in 1872 and enlarged in 1895 for 180 children. Mr William Beeston was the master, Miss Elsom the mistress, and Miss Dorothy Beeston the infants' mistress. Mr Beeston was the church organist and his daughter, Mrs Etty, kept up the family tradition until her death in the 1980s.

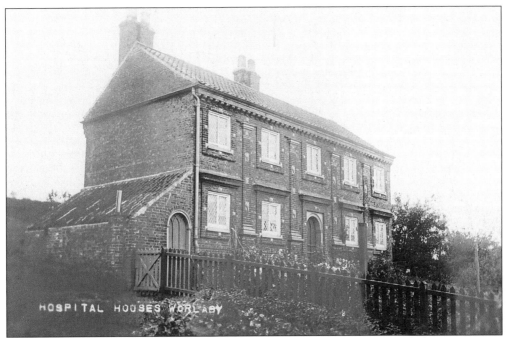

Hospital Houses, Worlaby. This, the oldest building in Worlaby, was built originally in 1663. It is understood the lord of the manor, John Bellasyse, who lived at the hall, founded the hospital to be occupied by four poor women, rent free. It was called a hospital but was actually almshouses.

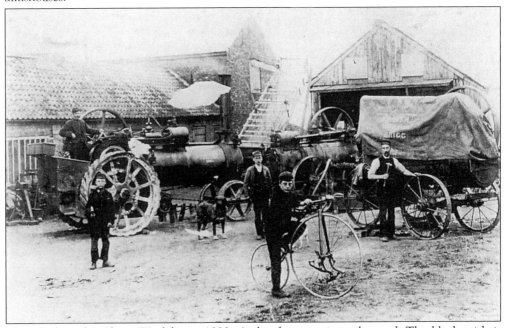

The Blacksmith's Shop, Worlaby, *c.* 1880. A threshing set is in the yard. The blacksmith is Joseph Smith, who is on the traction engine. His eldest son, Herbert, is near the dog, the youngest, Ellis, is on the pennyfarthing. The firm moved to Brigg in 1906 as agricultural engineers.

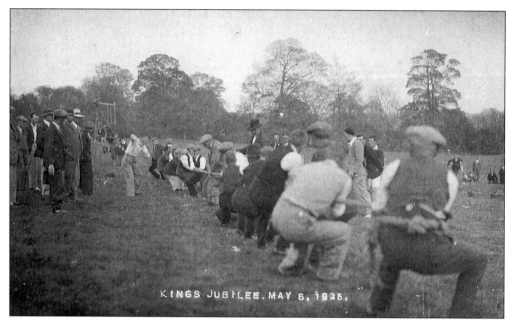

KINGS JUBILEE. MAY 6, 1935.

The King's Jubilee, May 1935. The celebrations started midmorning, with the main sports taking place in the afternoon in the park close to Worlaby House. It belonged to the estate which had been bought by Kings College, Cambridge. Tea was provided in the schoolroom for all the villagers and there was beer around the bonfire at night. It is said some men daren't go home afterwards!

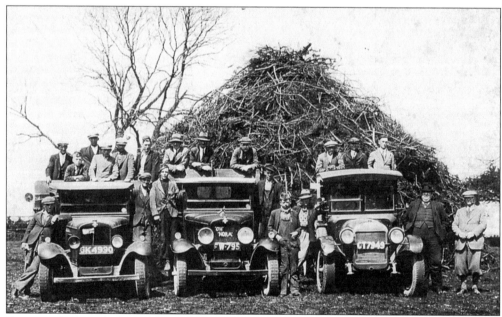

Estate workers made the bonfire, helped by other villagers in their spare time. It was built at the top of Middle Barn Hill, the highest part of Worlaby and when it was lit it could be seen for miles. All the wood was led from Elsham Carrs using lorries belonging to Ned Clark, the blacksmith.

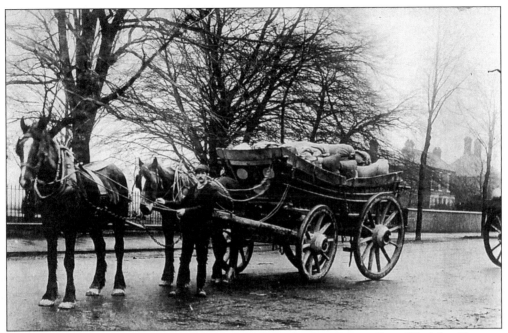

Fred Clark farmed one hundred and fifty acres of carr land at Grange Farm Worlaby. Here we see his waggon and horses on Wrawby Road, Brigg, with a load of grain en route for Bell's Mill.

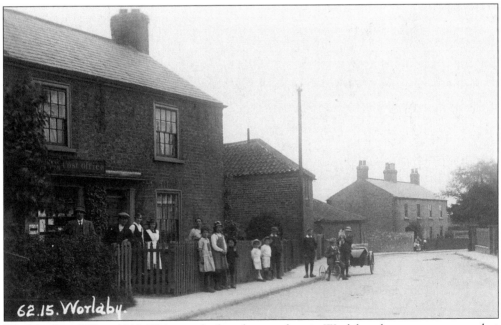

62.15. Worlaby.

Worlaby Post Office, 1919. This was the last shop to close in Worlaby, about two years ago, but this picture confirms there were plenty of customers for the post office on Main Street in the early part of the century. Mr Bradshaw was then the postmaster and is on the extreme left.

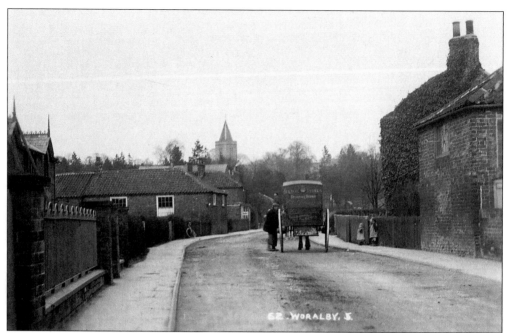

Main Street Worlaby, 1912. The horse and carriage is outside the post office and further away to the left is the Sunday school room for the Wesleyan chapel. It was pulled down soon after the Second World War. In the distance is St Clement's church.

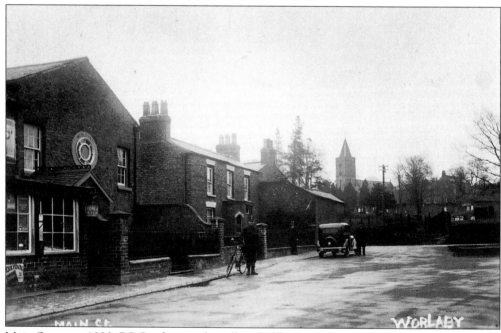

Main Street, c. 1930. PC Sanderson, the village bobby for Elsham and Worlaby, is outside the Wesleyan chapel. Next to it is Chapel House where one room was used by Dr Williams of Barnetby for his surgery. Mr Dyer, a forester, is waiting to go in, while Mr Brader the chauffeur stands beside the doctor's car. First on the left is Machin's shop which sold virtually everything. It was demolished in the 1970s.

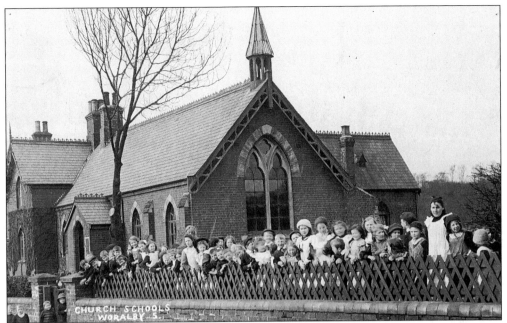

Worlaby School, *c.* 1912. The school dates from 1872 and was enlarged in 1884. The school bell was removed in the 1960s because it had become dangerous, but it is still on show in the school. The headmaster, Mr R. Lowe, had two assistants. The school house on the left of the picture is now a staff room and kitchen, and the upstairs is used for storage.

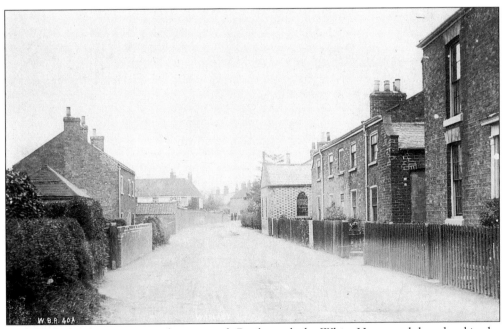

Low Road, Worlaby, 1911. Looking towards Bonby with the White House and the school in the distance. The chequered building on the right was originally a dame school, with Mr Clayton as headmaster. It closed in 1872 when the present school opened and became the reading room where men played dominoes and cards. It has now been demolished.

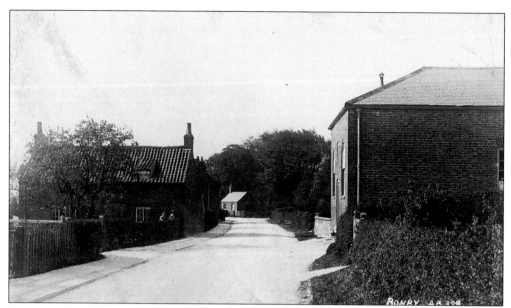

A very quiet scene on the main road in Bonby. The building on the right is the Methodist chapel which is still in use. The little reading room in the distance, and the cottages on the left, are no longer there, but the Haymaker public house has been built almost opposite the chapel.

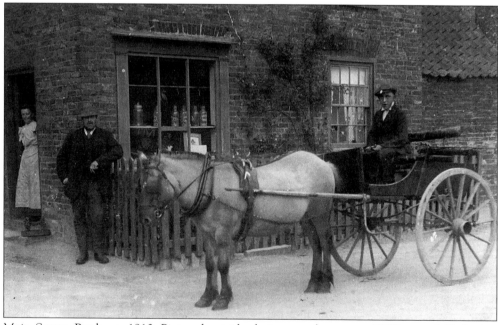

Main Street, Bonby, c. 1910. Pictured outside their general store are William and Catherine Marshall, with their son Harold Walker Marshall in the pony cart. This was the Sunday cart. A flat dray was used for business and they also had a small-holding at the rear of the shop. Harold and his wife Jessie took over the business and in the early 1950s incorporated the post office.

Ten
Scawby, Hibaldstow, Redbourne and Broughton

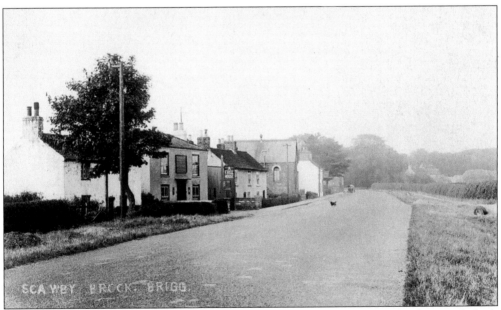

Scawby Brook, *c.* 1935. On the left is the King William IV public house, a free house, of which Arthur Walton was the licensee. It had previously belonged to Sutton Bean and Co. until 1924. Further down, the white cottage is the original Horse and Cart selling Sergeant's Brigg Ales; Arthur Miller was the landlord. The Primitive Methodist chapel in between the two pubs was built in 1879 and is still used for services.

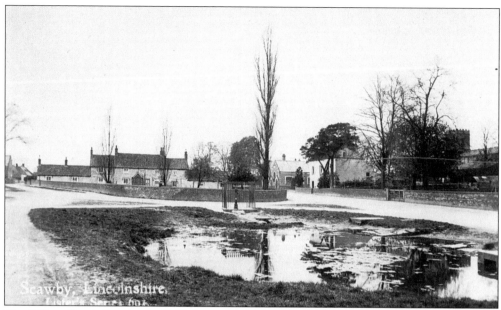

The Village Pond, Scawby. In 1953 the pond was filled in and the resulting grassed area became known as Coronation Gardens to commemorate the Queen's coronation and has become the village green. The pump remains a feature. Facing the pond are the almshouses which are still there, although no longer almshouses. The church, white house and the old school, can be seen to the right and remain little changed.

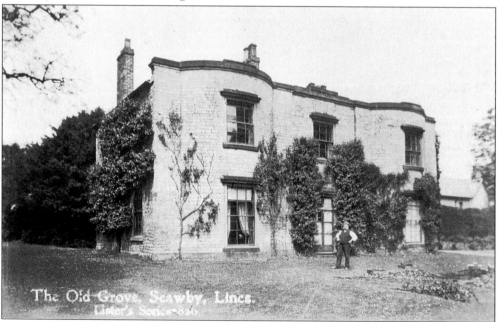

The Old Grove. The original Grove was purchased by Joseph Cliff, who built a new Grove, a fine Victorian mansion, completed in 1890. The Old Grove was demolished after the First World War and, it is said, parts of the building were used to build Grove Cottage. Joseph Cliff, who originated from Leeds, was a pioneer of the Scunthorpe iron industry. He lived at the Grove until his death in 1914, aged 73.

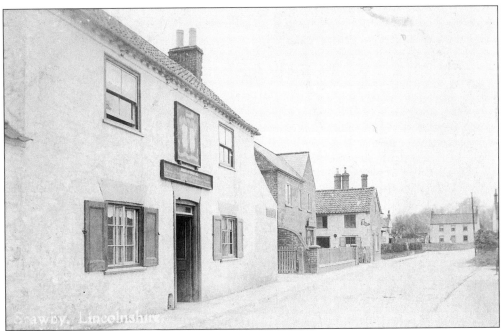

The Sutton Arms, Scawby, 1908. This property belonged to the Sutton Nelthorpe family, whose coat of arms is above the door. For a generation, the pub was run by the Whitehead family, who organised horse-drawn coaches to take people to Brigg on market day. Next door is the village shop, which is now run by the third generation of the Oglesby family, but the cobbler's shop next to that has been demolished.

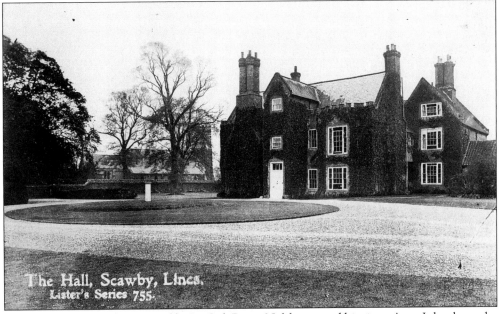

Scawby Hall. Presently occupied by Lt-Col. Roger Nelthorpe and his sister Ann. It has been the home of the Nelthorpe family for many generations and stands in a park of one hundred and seventy acres. The Nelthorpe family founded the grammar school at Brigg in 1669 and also provided an elementary school in Scawby.

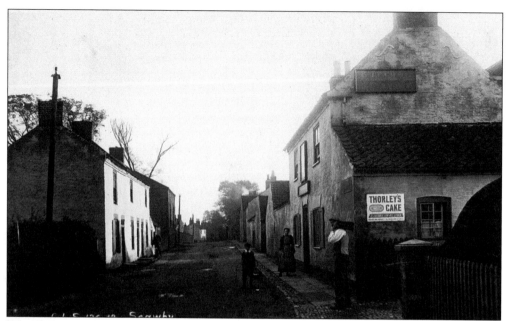

West Street, Scawby, *c.* 1920. This street actually runs north to south. Looking south, in this view, towards Sturton and Hibaldstow, the white cottages on the left were demolished in the 1930s and replaced by West Villas. Next is the Wesleyan chapel built in 1834. This fell out of use about 1930, became a school canteen in the 1940s and was taken down in the 1960s for road widening. The Sutton Arms is on the right.

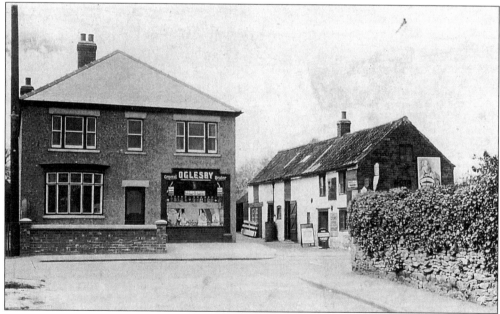

Oglesby's Shop, *c.* 1935. At this time, this and the post office were the only shops in the village. There was a small post office and sweet shop in Sturton, a mile away towards Hibaldstow. The buildings to the right were used as warehouses for the shop until demolition in the 1960s, when the shop was extended. It is still a thriving business today.

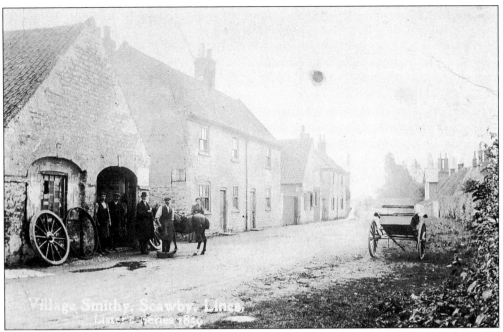

The Village Smithy. Church Street looking towards Brigg showing the smithy on the left. The main entrance at the front is not used now, but the smithy is still operational. The blacksmith lived next door. Nelthorpe's joiners shop is next, and like the blacksmith, he also lived in the next door cottage. Apart from better roads, the scene is remarkably similar today.

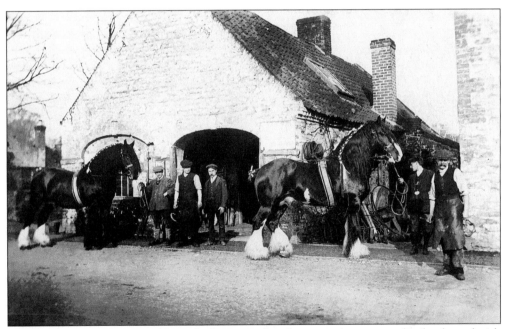

Once a common sight in rural Lincolnshire, two shire horses with manes and tails adorned with ribbons, possibly for a local show, wait outside the smithy to be shod. The blacksmith on the extreme right is Mr Ira Elwood.

Scawby Post Office, *c.* 1930. Situated on the corner of Church Street and West Street, Mrs A. Mapplethorpe was the postmistress. The poster on the left of the building is advertising the programme at the Grand Cinema, Brigg. The extreme right of the building was demolished in the 1960s for road widening. When the business was transferred to Chapel Lane, it became a guest house. To the left is the old infants' school built in 1912.

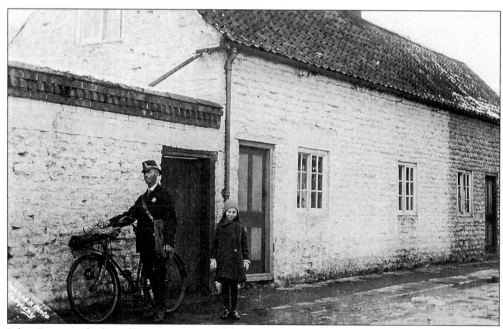

John Prestwood, the village postman and barber, with his daughter Connie pictured outside their home in Vicarage Lane, now aptly called Prestwood Cottage. The year is around 1910.

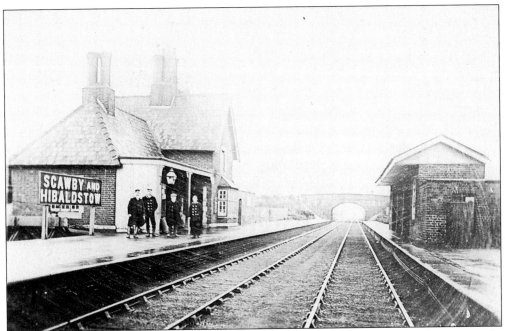

Scawby and Hibaldstow Station. Built in 1849, it was situated between the two villages actually in Hibaldstow parish. Looking towards Brigg, the station master's house is attached to the station buildings and a shelter is provided for passengers on the other side. The station closed in the 1960s – another victim of Dr Beeching.

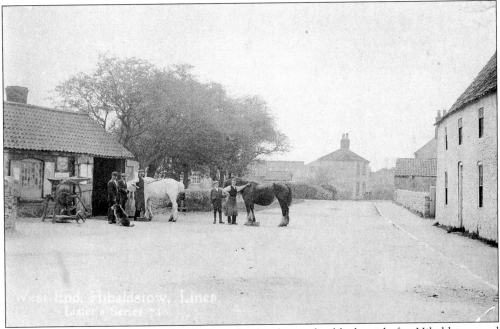

West End, Hibaldstow, c. 1905. Mr Sam Stothard was the blacksmith for Hibaldstow and Redboune in the early years of this century. The blacksmith's shop pictured to the left, was closed two or three years ago and is now used for car repairs. The trees have been taken down and there is a stackyard in their place.

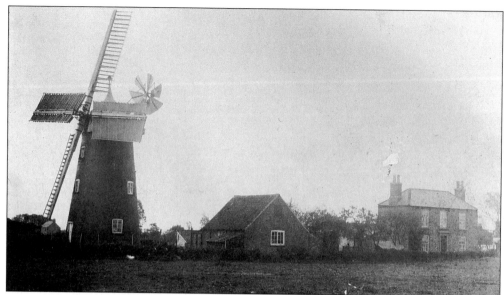

One of the three windmills which worked in Hibaldstow during the nineteenth century and typical of hundreds which once operated in the county. The white ogee cap was so common that it became known as the Lincolnshire cap. The fantail, which turned the sails into the wind automatically, was caught out in a thunder storm around 1920 and the cap and sails were destroyed. The mill was subsequently demolished.

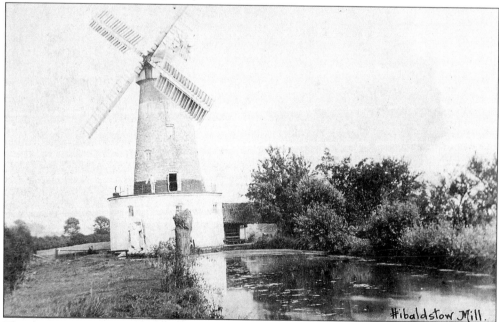

This unique structure is a scheduled monument. Constructed of local limestone, it was built in 1802 and combined both wind and water power. It was updated in 1837 when the upper storey was added in brick. The two-storied round base contained the water powered plant and cramped living quarters. The sails powered two further pairs of stones in the third floor. The water wheel and sails had been removed by 1913. The fascinating building is currently being restored.

114

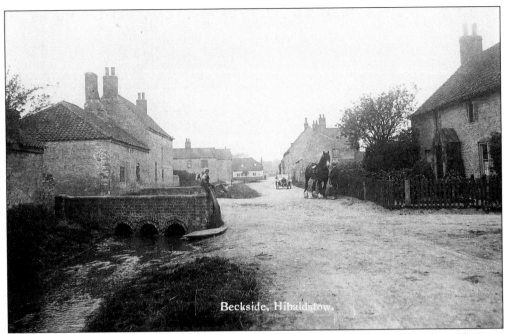

Beckside, Hibaldstow. The little stone bridge on the left leads towards the church. Beck Farm, just beyond the bridge is now a private residence. Looking into the village, the photographer's car can be seen in the distance on the dirt road.

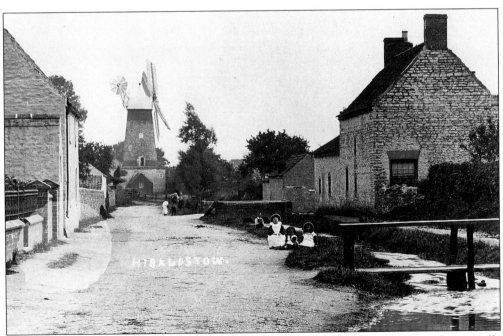

Beckside looking in the opposite direction, *c.* 1905. The beck flows past the mill and eventually into the River Ancholme. The lane ends at the mill, but the bridge takes you into Ings Lane. The children add charm to this idyllic scene.

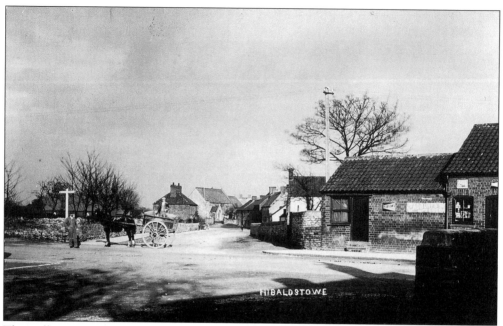

The miller's cart of Alfred Brumfield is at the cross-roads in the centre of Hibaldstow. The church of St Hybald can be seen without its tower, which fell on July 1875. The shop on the right is now a newsagent. The signpost indicates Brigg to the left and Redbourne to the right.

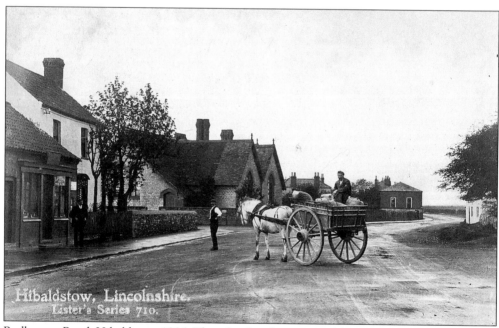

Redbourne Road, Hibaldstow, 1906. The school in the centre of the picture was built in 1874 at a cost of £900 and enlarged in 1895 for two hundred children. The average attendance in 1906 was one hundred and twelve, when William Goode was the master. It closed in the late 1970s soon after it celebrated its centenary. The miller's cart belongs to Mr Reeson who had the mill in Beck Lane.

Redbourne Road, Hibaldstow, 1937. Looking into the village from Redbourne, Greenfield Farm is in the distance, which is still a working farm today. The majority of these stone houses have been demolished, replaced by council housing in the 1960s. Those that remain are beyond the second telegraph pole where the village post office can still be found today.

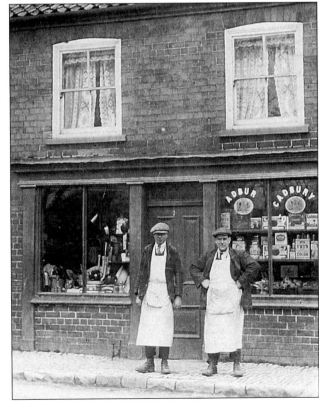

Mason's Shop, Redbourne. It is thought the man in front of the door is Mr Drury, with Ernest Atkinson on the right, who later became the licensee of the Wheatsheaf at Hibaldstow. The shop, a grocery and drapery business, was situated on the High Street. There were workshops at the back, as Mr Mason was also a builder and contractor.

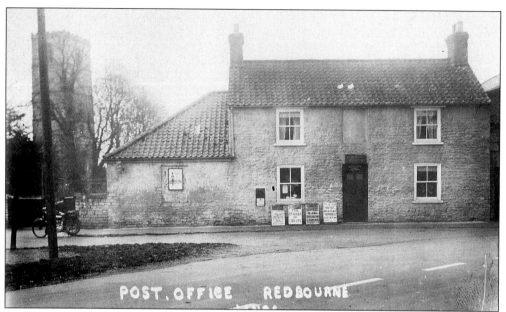

Redbourne Post Office, *c.* 1926. The postmistress was Eva Walker, wife of the village blacksmith Enoch Walker and, as the boards outside suggest, her shop was also the place to buy a newspaper. The post office later transferred to another property further down School Lane. This building was demolished after the war. There is no post office in the village today.

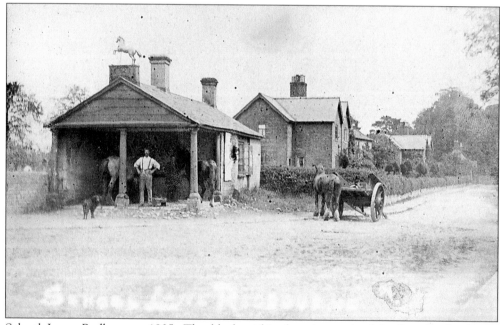

School Lane, Redbourne, 1905. The blacksmith's shop is on the left. Sam Stothard, the blacksmith, would have been a very busy man on account of the large farms around. The shoeing was done in the open part at the front, the anvil, bellows and forge were at the back. The smithy closed in the 1950s, but the building remains, complete with the model horse on the top.

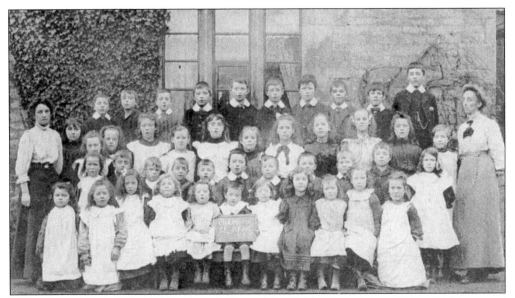

Redbourne School, 1909. The headmistress was Mrs Mary Ellis and the children look neat and tidy for the photographer. The school was built in 1840 with funds from the tenth Duke of St Albans and enlarged in 1891. The average attendance in 1909 was forty two. It was replaced by a more modern school in the 1930s on a different site, but this too has since been closed.

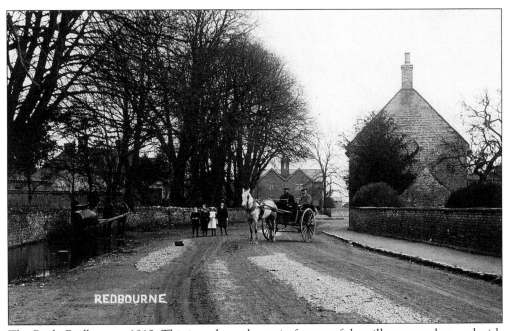

REDBOURNE

The Beck, Redbourne, 1912. This is perhaps the main feature of the village nowadays and with plenty of ducks. Looking towards Hibaldstow, the building on the right was taken down when a relief road was constructed. A water cart can be seen to the left at the beck. The stony roads were quite adequate for the horse-drawn transport of the day.

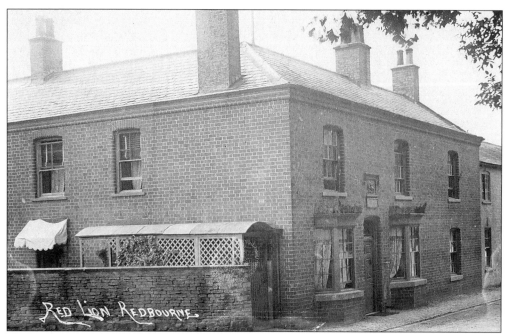

The Red Lion, Redbourne. The pub was originally part of the Duke of St Albans estate until it was sold in the 1920s. The sender of this postcard states that it is the inn where the Duke's family stay when they visit Redbourne.

Squire Charlesworth bought the Red Lion. It was privately owned until just before the war. He altered the frontage and extended it to the building next door. During the war it was a popular place with the airmen from nearby Hibaldstow aerodrome. This part of High Street was relieved of through traffic when the relief road was built.

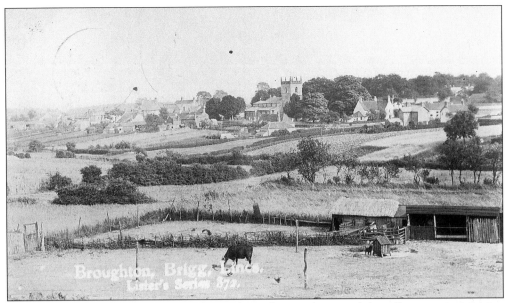

Broughton, *c.* 1906. A general view of Broughton showing how rural the village was, comprising mainly of fields, farms and cottages. Looking south, the church can be seen in the centre of High Street with Town Hill to the left. All this area is now covered by housing, some of which was built in the 1920s and 1930s, but a massive expansion of the village started in the 1960s and is still ongoing.

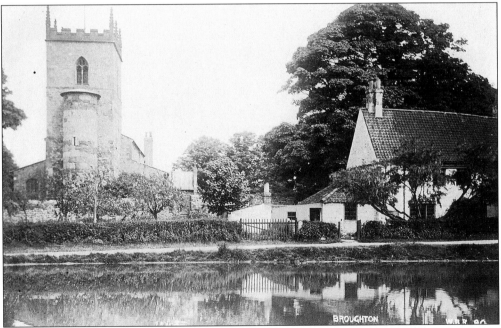

The pond contributes to this tranquil picture of the centre of the village. St Mary's church is a Saxon building with a stone turret attachment, one of only seven in the country. To the right is Pond Farm, the property of the Earl of Yarborough, which disappeared long ago, as did the pond.

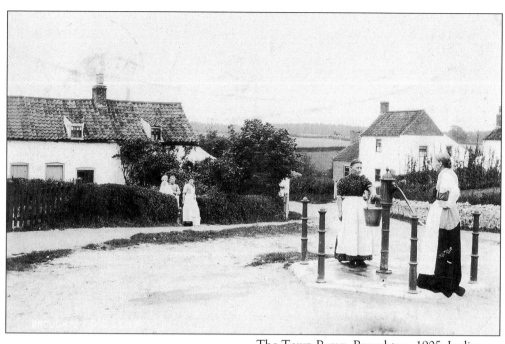

The Town Pump, Broughton, 1905. Ladies wearing traditional white aprons draw water from the pump on Town Hill, water that was always cool and lovely to drink. The cottages on the left gradually fell down and were replaced by a bungalow in 1957, after seventeen lorry loads of rubbish had been removed from the site. The pump remained until the 1960s, when it was removed for road widening necessitated by the increase in housing.

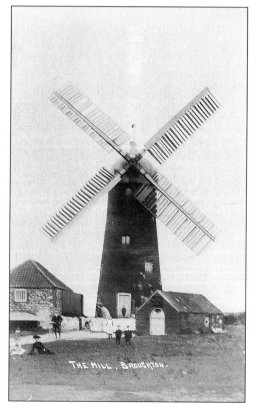

THE MILL. BROUGHTON.

Broughton Mill. A tower mill which stood on the east side of Mill Lane, was built to replace a post mill blown down in 1812. The mill was operated by a succession of millers, latterly by George Ayre and his son, Harry, until the First World War. A water-powered corn and textile mill also operated in the parish until 1816.

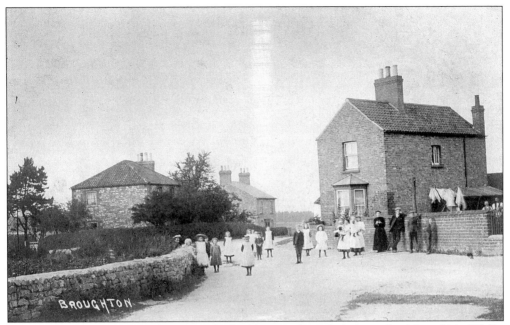

High Street, Broughton. Looking east, the building on the right belonged to Mr and Mrs Wells. Mrs Wells made the room with the bay window into a fried fish shop, which opened on Friday and Saturday nights. She provided a bench outside where you could sit and eat them and you always got a large helping. To the left is Yew Tree Farm and Town Hill, with Mill Lane to the right.

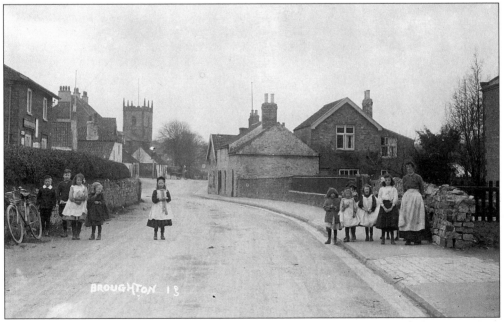

High Street, Broughton, *c.* 1913. Fascinated children adorn this picture of High Street, looking west towards the church. The house on the left was the police house on the corner of Scawby Road. One of the cottages to the right was a little draper's shop and one a grocers. They have now been replaced by the Mini-Market.

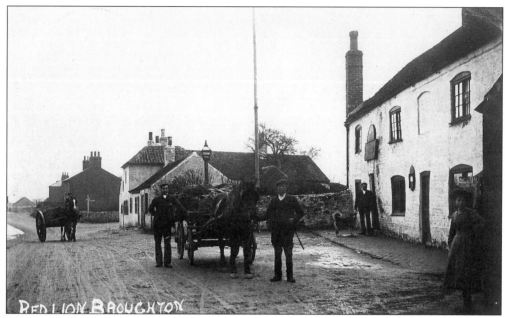

The Red Lion, Broughton. Small whitewashed stone cottages typifying rural Lincolnshire in 1905, the date of this picture. Fred Ayre, a coal and general haulage dealer, stops with his horse and dray outside the Red Lion. It is thought to be the landlord, John Gardham Shaphard, in the doorway of the inn, with his dog.

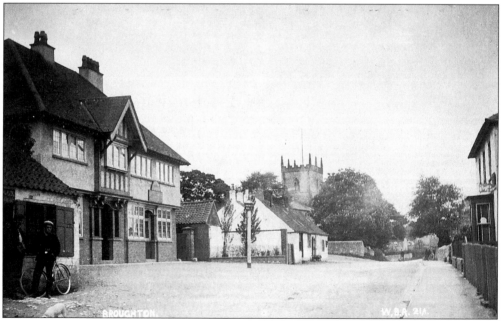

The new Red Lion had just been built when this picture was taken just before the First World War. The small white stone building between it and the church was the village smithy, where Jim Bainton, a fine craftsman, was the blacksmith. When he died in 1955, the smithy was closed and eventually pulled down.

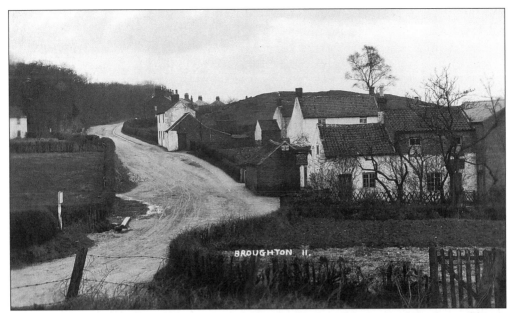

Appleby Lane, Broughton. Looking north, the original Dog and Rat is on the right, a pleasant pub where the cricket club meetings were held. On the opposite side of the road, the drinking trough for cattle and horses can be seen, which was presented by Mr Skevington, landlord of the Angel Hotel, Brigg in 1908.

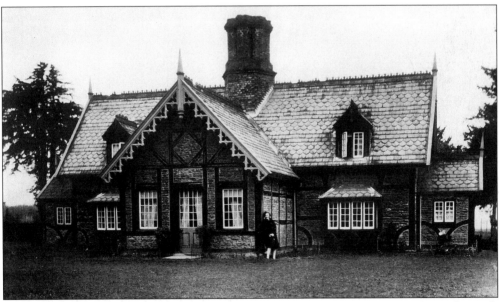

Briggate Lodge, *c.* 1930. One of the lodges on the Manby estate belonging to the Yarborough family. It was occupied by workers on the estate, which was extensively woodland. Broughton woods were famous for lilies of the valley. After it fell into disrepair, it was replaced by a prestigious hotel, the Briggate Lodge Inn, with a golf course in the adjoining grounds.

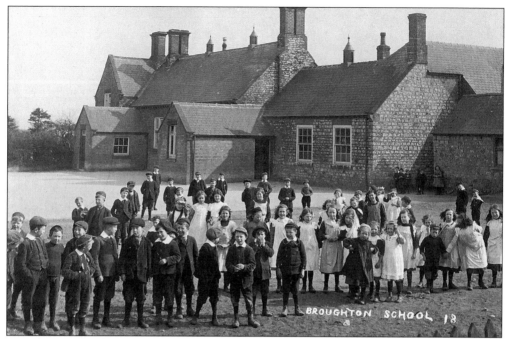

Broughton School. It was known as the Countess of Yarborough's school because it was endowed by the Yarborough family. This photograph dates from around 1913 when the headmaster was Mr Dobson, and shows the children in the playground. The girls wore white aprons and stockings, the boys wore caps. Although no longer a school, it is still used for education as an annexe for an agricultural college.

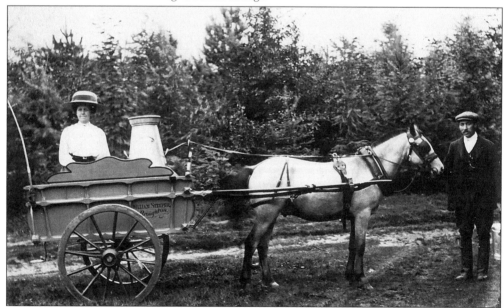

William Steeper, the dairyman, seen here with his wife Kate seated in the delivery cart in about 1920. They lived in a cottage on the High Street in Broughton. Kate Steeper was a regular attender at chapel, where she sang in the choir. The other dairyman in the village at this time was William Rossington.

126

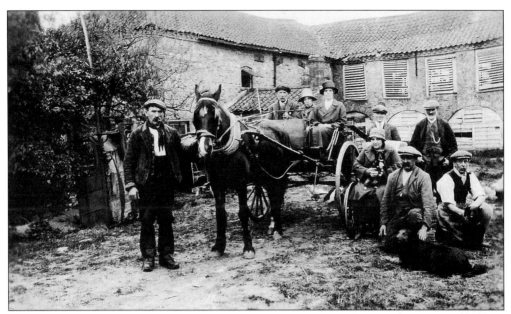

The Tannery at Castlethorpe. Charles Tacey was the last tanner at Castlethorpe, once a thriving business which ceased in 1966. Charlie Bowers of Broughton is holding Tommy the horse. It was given one pint of beer a day by its owner Jo Burman, pictured in the trap with his wife and daughter Kate. Charles Tacey is in front of the group to the right with his dog. Behind him is his daughter, Iris. All the men were workers at the tannery.

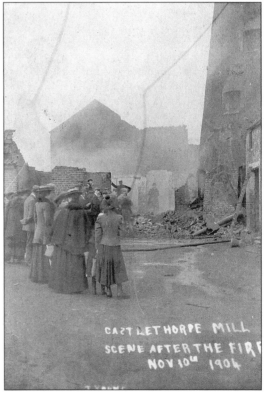

Castlethorpe Mill. This was the scene after the fire, 10 November 1904. The mill at Castlethorpe, a hamlet between Broughton and Brigg, was a four sailed tower mill built in 1804 and owned by the Gummerson family until 1905. The Spencer brothers were millers there until 1922, using steam power, but Arthur Johnson later had an oil engine until the 1960s, when the mill was converted into a hotel.

Acknowledgements

Many local people have suggested over the years that we produce a book using the collection of local old pictures that we have gathered. The opportunity arrived and sounded straightforward. However, without the help of several folk in and around Brigg we would have struggled to complete the task. We would like to express our thanks to the people who lent us postcards and photographs of their villages which have enhanced the picture quality of our book. Our thanks must also go to the people who live in these communities. They have given us their time and local knowledge to allow us to get to the heart of each village. Our particular thanks must go to the following: Mrs Mary Vessey of Broughton, Mrs Betty Dixon of Bonby, Mr Ken Braithwaite of Barnetby, Mrs Mary Hannath of Cadney, Mr and Mrs Thorpe of Elsham, Mrs Gladys Hinch of Grasby, Mr Philip Wood of Hibaldstow, Mrs Ellen Williamson of Howsham, Mr Henry East of North Kelsey, Mrs Greta Birkenshaw of Scawby, Mr Len Clarke of Worlaby, Miss Nan Machin of Worlaby, Mr Charles Gillatt of Wrawby, not forgetting Mrs Marjorie Thompson of Brigg, who over the years has been a constant source of local information. Last but by no means least a special thank you to a dear sister, Christine Watkins, for her typing and computing skills needed for the final 'polish'.

John and Valerie Holland